BENEATH THE ROSES

W9-BIR-937

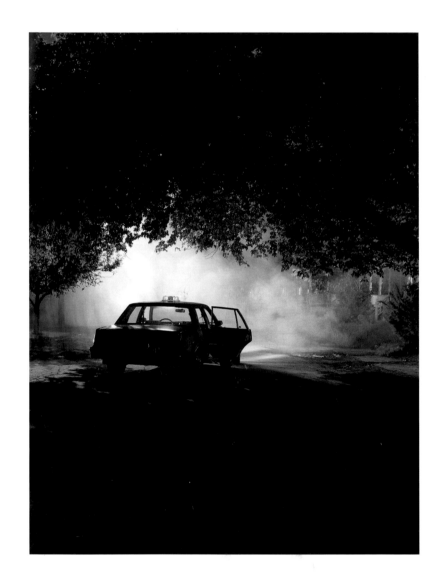

BENEATH THE ROSES

GREGORY CREWDSON

ESSAY BY RUSSELL BANKS

ABRAMS, NEW YORK

CONTENTS

GREGORY CREWDSON: BENEATH THE ROSES

BY RUSSELL BANKS

The frequently made comparisons of Crewdson's work to the movies—Steven Spielberg, Wes Anderson, David Lynch, etc.—are suggestive and derive from the "look" of the pictures, which resemble no visual artifact made by man so much as 1950s Technicolor movie stills posted in the lobby of the Palace Theater in Lake Placid, New York, or the Star in Concord, New Hampshire, or the Capitol in Montpelier, Vermont. The small-town theaters of my boyhood and adolescence. They're like stop-action shots, inviting one, *obliging* one, especially perhaps if one is an adolescent boy, to concentrate on the details.

The comparisons to movies derive also from the way in which the contents of the pictures are assembled and staged—the special way in which the photographs are made. They do not conceal their staging (the staging, its artificiality, is practically flaunted), but like movies they are obviously expensive to produce and require an enormous amount of planning and huge crews and vast amounts of equipment and machinery. And similarly, their production depends upon trust and collaboration among many people with many different skills and types of expertise. They are assembled like soundstages, most of them built in and around the decaying mill town of North Adams, and Pittsfield, Massachusetts, with the characters (and they are characters, rather than subjects) played by local citizens and sometimes by professional actors. A single shoot can force a town to reroute automobile traffic for entire days. So it's natural to want to compare them to the movies.

Yet it seems to me that inasmuch as the viewer is required to do a crucial part of the creative work him- or herself, Crewdson's photographs engage one's mind more like good fiction than movies. When we watch a movie, after all, we are prohibited from using our imagination. It's not part of the deal. It's all done for us. Moviegoing is essentially a passive experience. What's on the screen enters our eyes and ears and fills our minds entirely, leaving us with no room or choice but to check our imaginations at the door. Movies, in contrast to the glossy stills posted in the lobby to announce and advance them, nullify both memory and hope. We can't bring our personal pasts, our memories and erasures, our fantasies and denials, our dream lives and our nightmares to the movies and plug them into the narrative, using the material of our secret inner lives to fill out and amplify the fast-moving, sound-tracked imagery on the screen and give it personal meaning, the way we do when, silently, slowly, in complete control of our rate of perception, we read a novel. Or the way we do when we peer into the photographs made by Gregory Crewdson.

For as much as Crewdson's secret inner life is surely revealed by his photographs, on viewing them one's own secret inner life is necessarily revealed, too—at least to oneself. And revelation produces change. Movies do many things to and for us; but they almost never change us. Not at the moment of viewing, anyhow. Later, maybe, they can, after they've been stored for a while in our memory banks and have been compounded there and can be drawn upon as if they were part of our remembered experience of the world; as if we, too, had hung out with Humphrey Bogart in Casablanca in 1942 or had watched Atlanta burn. Simply, we don't bring that part of ourselves to the experience of going to the movies. Movies provide no half-completed alternative reality ready to have its blanks filled in; no fictional world where we can reside long enough to furnish it with our preexisting memories, dreams, and reflections.

Further to that, a single isolated photograph by itself, even one of Crewdson's, cannot change the viewer or the photographer himself, any more than a single chapter from a novel can change the reader or the novelist himself. No, you have to see or make a *series* of pictures; you have to read or write the entire novel. You have to expose yourself to an alternative world, a *fictional* world, if you will, and enter it; and not only that, you have to live there for a long time, for hours and days and weeks and even longer, years, and fill it out, and in, with your own imaginings. A glance, a quick look-see, will not do it. And this is as true for the photographer himself as for the viewer, as true for the novelist as for his or her reader.

Thus it's as if Crewdson, working in extended suites or series of pictures that are exceedingly difficult and time-consuming to prepare and stage, were making his pictures, not so that we, his audience, can see what would otherwise be invisible to us, but so that he himself can see. He's making an artificial, life-size world that he can live in, albeit temporarily. For, having *seen* that world, having *lived* there amongst its ambiguities and uncertainties, he is changed and can begin to look again. Having seen his made world, he can begin to imagine anew the world at large; and then, after each sequence is completed, having imagined the world in a new way, he will find himself a bit closer to the way he (and we) imagined it as a child. Well, not quite as a child. As an adolescent boy, maybe. At least in my case. But perhaps his, too. A thought I'll return to later.

Historically, most photographs, even staged cinematographic photographs like those of the nineteenth-century Victorian Henry Peach Robinson, for example, or some of Crewdson's near-contemporaries like Jeff Wall and Cindy Sherman, are *complete*: They purport to tell the whole story. Whatever's left out of the picture is ipso facto rendered insignificant. Not worth signifying. They are *tableaux mourants* and possess the unnatural stillness and emotional certitude of a diorama. It's why photographs, especially staged or set-up photographs, no matter how much they resemble or reference scenes from real life, so often and so easily misrepresent actuality. That is to say, they misrepresent one's *lived* experience of actuality. This quality of seeming to tell the whole story, of seeming to displace or substitute for reality—if you can't see it, then it doesn't exist—contributes mightily to the essential, perhaps inescapable, sentimentality of photographs. Inasmuch as most photographs stop time, they deny that there's more than meets the eye. They possess an infatuation with the particular, so that what you see is what you get. What you see is what there *is*. Vladimir Nabokov once noted that as the novel is to reality, movies are to the novel, i.e., a sharp reduction and simplification of the infinite plenitude of human existence. I might extend that equation and add that as the novel is to reality and movies are to the novel, photographs are to movies.

But not Gregory Crewdson's photographs. No, it's the *incompleteness* of Crewdson's photographs that I love. One almost hesitates to call them photographs; better perhaps simply to call them pictures. Which of course raises the question of what to call *him*, the maker of these pictures. He's more a cartographer of the quotidian than a mere photographer, a cartographer of the specifically American quotidian, I should say, which is violent, melancholy, and corrosively lonely. To me, his is not a bleak or pessimistic view of Americans, however, and it's certainly not cynical. It's merely accurate. For these people are not being represented by his pictures; they're being presented. And, most importantly, presented with compassion, freed of judgment. The pictures that make up "Beneath the Roses" show us the Americans who vote against their own self-interests and principles or don't vote at all, who hurt and abandon one another with shocking precision and ease, who surround themselves with shiny, manufactured objects, fluorescent kitchens and bathrooms, gleaming tile floors, bedrooms where no one has slept soundly for years, TVs on at 5:00 A.M. and no one watching, overstuffed closets, darkened dining rooms, and mirrors that reflect a face guilt-ridden and apprehensive or else a person's inadvertent back. Their cars seem always to have a door hanging open, the motor left running, as if ready for a quick getaway, someone in flight either from a bad marriage or a stick-up. Or as if the driver suddenly remembered a long-forgotten crime—suffered or committed, it doesn't matter—and has pulled over to the curb, flung open the door, and, heart pounding, has fled into the night, filled with fear and shame.

Crewdson is what the poet Charles Olson said a poet must be—"an archeologist of morning." He's digging through the ruins of 5:00 A.M., excavating the dark, moldering remnants of Ronald Reagan's sunlit morning in America; he's mapping and measuring the tumbled down

cellar walls of our New Jerusalem, our City on a Hill, our New World, everything that, almost before we the people were born, got corrupted and shoddy and old so fast and turned the American Dream into the American nightmare. And like any nightmare, his pictures seem to have no beginning or end. They reach back prior to when we first dropped off to sleep, back to the mists of our early history, and they promise not to end when we wake. In a Crewdson picture, terrible things have been done to people by people in America for a very long time, whole centuries, and you can tell at a glance that we Americans will continue to do terrible things to one another until there are no more of us around. It's our human nature, one might say, a thing that will not change, except to grow worse. There is no foreground or background to it, no before the Fall or after. We Americans are permanently fallen creatures who possess no memory of paradise, only a fantasy of it. And the fantasy, unrealized, perhaps unrealizable, turns us violent.

Thus the pictures exist in time, yes, but with no beginning, middle, or end. They are antinarratives. Beginning, middle, and end lie elsewhere, outside the frame. The pictures merely point that way; they neither withhold nor disclose it. And just as in a dream or nightmare, just as in psychoanalysis, for that matter (and it might not be coincidental that Crewdson's father was a psychoanalyst), no detail is meaningless and all details are equally significant. Everything placed inside the frame of the picture has equal meaning and importance in the world that exists outside the frame. Among the details there is no hierarchy of value or allusion. It's one reason they are so carefully staged and why they are shot on film and digitalized afterward, simultaneously flattening the perceptual field and heightening the details that fill it. Not satisfied, therefore, with merely being antinarratives, the pictures are antisymbolic as well.

This refusal to rank value and allusion among the elements of the picture is not a quality one normally associates with photographs, staged, documentary, or candid. Nor is it a quality one associates with fiction or poetry. It is, however, an aspect of certain symbol-resistant abstract paintings, the work of painters like Helen Frankenthaler or Jackson Pollock or Mark Rothko or Jules Olitski, the Abstract Expressionists and the Minimalists who covered their canvases with paint all over and out to the edges of the canvas, such that every square inch of the painting is as meaningful and important and necessary as every other square inch. Critics usually associate Crewdson's work with that of strictly figurative painters, however. They especially compare him to Edward Hopper. Crewdson himself has said, "Hopper has been profoundly influential to me as an artist Emerging from a distinctly American tradition, Hopper's work deals with ideas of beauty, sadness, alienation, and desire." It's an easy connection to make. Although much reduced and simplified, the tone, atmosphere, light, composition, and imagery of a Hopper painting do combine in many of the same ways as in a Crewdson picture. And there are those "ideas of beauty, sadness, alienation, and desire." Yet Hopper's expression of those ideas stands in sharp contrast to Crewdson's, it seems to me, inasmuch as Crewdson never sentimentalizes them. One never suspects Crewdson of self-pity or—except for the scale of his pictures—of self-importance, the way one might suspect it of Hopper. Crewdson's view of "beauty, sadness, alienation, and desire" has an ironic, almost self-mocking edge to it, a sharpened blade that cuts through the uneasy melancholia that suffuses his pictures, giving them a kind of tough-love realism and sly humor that contradict or at least correct Hopper's softer, more illustrative gaze.

Also, as I said, the pictures made by Gregory Crewdson arrive in clusters, bunches, suites, sequences. They're almost never presented as single units, as *isolatos*. And over the years in his work so far there is a progression, if not progress (although I'll try to make a case for that further on), from one sequence to the next. They do not so much differ from one another in subject, format, or artistic intent as grow out of one another, with each new sequence providing the working assumptions for the next. Thus, one senses that the process of making the photographs changes the maker himself, altering the shape of his imagination and the content of his secret inner life,

so that afterward, when he returns to his camera again, even if he's looking at the same thing, or nearly the same thing, he does not see what he saw before. There is a different context now. Having made a set of pictures, he sees the world freshly and, moving on, gets to start anew.

So it must be very exciting to be Gregory Crewdson. It's as if the making of his pictures, conceived and executed in sequences, has taught him each time out and after the fact what it was he meant to do but didn't, because he couldn't quite *see* at the time what he was reaching for, until he had failed to reach it. Or, more accurately, until he had seen it and found it wanting. It's as if each discrete series of pictures, from the early work of the late 1980s to "Natural Wonder" and then "Hover" and "Twilight" and "Dream House" and now these magnificent pictures, "Beneath the Roses," were made in order to clear the ground and make room for the next, yet-to-be-imagined series of pictures.

They weren't, of course. That may be the result, the use made of them by their maker—change, self-renovation, and renewal—as well as the use made of them by their viewer, but I doubt it was the deliberate intention behind the making. No, I'm sure that at the time of their making the photographs were felt and understood by Crewdson as ends in themselves and that the overall sequence was viewed as a completed, self-contained effort. Which is not true of the individual photographs, however. Taken individually, they appear to have been conceived, like chapters in a novel, as parts of a larger sequence meant to be greater than the sum of its parts.

And the sequences indeed are greater than the sum of their parts. As a novel is greater than the sum of its chapters. And though Crewdson's individual photographs flirt with autonomy in a way that the individual chapters of a novel normally cannot, the analogy of single pictures to single chapters of a novel is useful if you think of the chapters as having been plucked more or less at random from different parts of the novel, with many episodes and events, perhaps the majority, missing, inviting you the reader, you the viewer, to fill in the missing parts.

It's an essential element of their mystery and beauty, that incompleteness. Crewdson's individual photographs, in that sense, are not partial or unfinished episodes; they're events that have been interrupted. Story *interruptus*. Such that, if we want the whole story, we need to consider the entire series or sequence of photographs. We have to take in the pictures as a whole, although in no particular order.

In sum, then, Gregory Crewdson's pictures are like movies, but mainly in the way they *evoke* movies; and, yes, they are like written fiction, but only in certain epistemological ways. They resemble the staged or cinematographic photographs made by other contemporary artists, yet they evade the emotional certitude of those photographs and their postmodern, appropriative zeal for the banal. If his pictures meet the test of all photographs, it's only inasmuch as they rely upon a camera lens, among other devices, for their existence. And if they remind us of certain famous paintings, it's only by allusion, as with Hopper and other American Realists, and by their stubborn resistance to symbolism, their insistence on a flattened field of meaning, as with the Abstract Expressionists.

We speak of his work this way because, as one critic has noted, Crewdson doesn't *take* pictures, he *makes* pictures. Which inclines us to consider them in terms of what they are like, instead of what they are. But all obvious sources, similarities, and references aside and despite his many imitators and growing influence, Crewdson is *sui generis* and inimitable. He is almost too much at one with his work for useful comparison or imitation. "It's all about creating your own world," he has said. "It's a setting to project my own psychological dramas onto." In a sense, then, his is a performance art, and "Beneath the Roses" is not *like* an opera, it *is* an opera, one performed sometimes in a large gallery or museum in grand style with full orchestra and chorus, as it were, or sometimes more modestly like this, in a book. And we are not so much viewers of his work as its audience.

Borrowing, as all opera does, from every medium—fiction, film, theater, painting, and photography—"Beneath the Roses," taken as a whole, is a highly contrived, arbitrary-seeming narrative, staged in a way that both tests the limits of realism and makes no effort to disguise its artificiality. Emotions run high throughout, especially longing and fear and regret. It's an opera, after all. Mortality lurks sulking in the wings while the erotic plots betrayal at stage right and violence, with vengeance on its mind, awaits its turn to enter. Crewdson has been accused of being melodramatic, an accusation commonly made of opera, but those of us who love opera understand that the melodrama is merely a necessary means of encouraging the human voice to perform at its most moving and beautiful pitch, tone, and timbre. We are moved not by the melodrama, but by how bravely or badly the characters on stage respond to it. We are moved, in other words, by their performance. And so it is with the characters who populate the pictures of "Beneath the Roses." It's their stoical, open-eyed response to their plight that moves us, not the plight itself.

We might note that Crewdson meticulously documents with photographs and text the composition of his pictures, recording the process entirely from first conception to completion, and this, too, suggests that the final exhibition of the pictures is in fact a performance. Recording the process is an integral part of the preparation—rehearsals, if you will. As increasingly he has gained control over and access to the physical materials required by his operatic art (large indoor and exterior sets, elaborate stage lights, scaffolding, smoke machines, storyboards, warehouses filled with props and costumes) and the people he needs for staging it (carpenters, painters, gaffers, lighting technicians, set designers, and, of course, the performers), his work has evolved from single tunes hummed in his earliest pictures to the solo arias of "Natural Wonder" (1992–97) to the chamber music of "Hover" (1996–97) to his first full-scale operas, "Twilight" (1998–2002) and "Dream House" (2002), and now this, "Beneath the Roses," which we might consider his masterpiece so far.

Finally, I don't think it's irrelevant to mention that long before Gregory Crewdson became renowned as an artist and a distinguished professor at Yale, a married father respectably entering middle age, he was in the most literal sense a performer. As a teenager in Brooklyn in the mid-1970s, he and four friends founded a band, the Speedies, a post-punk, power-pop group that played at Max's Kansas City and the Bottom Line, had a devoted following in the New York area, was glowingly reviewed in *Variety*, and made records that are still treasured by fans and power-pop aficionados today. One of the Speedies' most popular songs, "Let Me Take Your Foto," has recently been remixed and used in a TV ad for Hewlett-Packard. I mention this for two reasons. First, it points to an early impulse to evoke strong emotions from strangers by means of performing before them, albeit in a way that could not last much beyond adolescence. Also, as I noted earlier, when one has looked long and closely at Crewdson's pictures, when one has taken up residence in that world, one finds oneself feeling emotions that have been lost or repressed since childhood. Not quite since childhood. Since adolescence, perhaps. The kind of attention these pictures require—a hard focus on the details, an openness to ambiguity, mystery, and paradox, easy access to feelings of regret and loss and loneliness, along with a cold fear of sex and a fascination with its heat—this is the kind of attention we like to think we have outgrown as adults. Yet without it, without bringing it every day of our lives to the world we live in, we are less than human. Somehow, by making his amazing pictures, Gregory Crewdson has sustained and nourished that quality of mind and has made it possible for us, his audience, to do so also.

BENEATH THE ROSES

I.

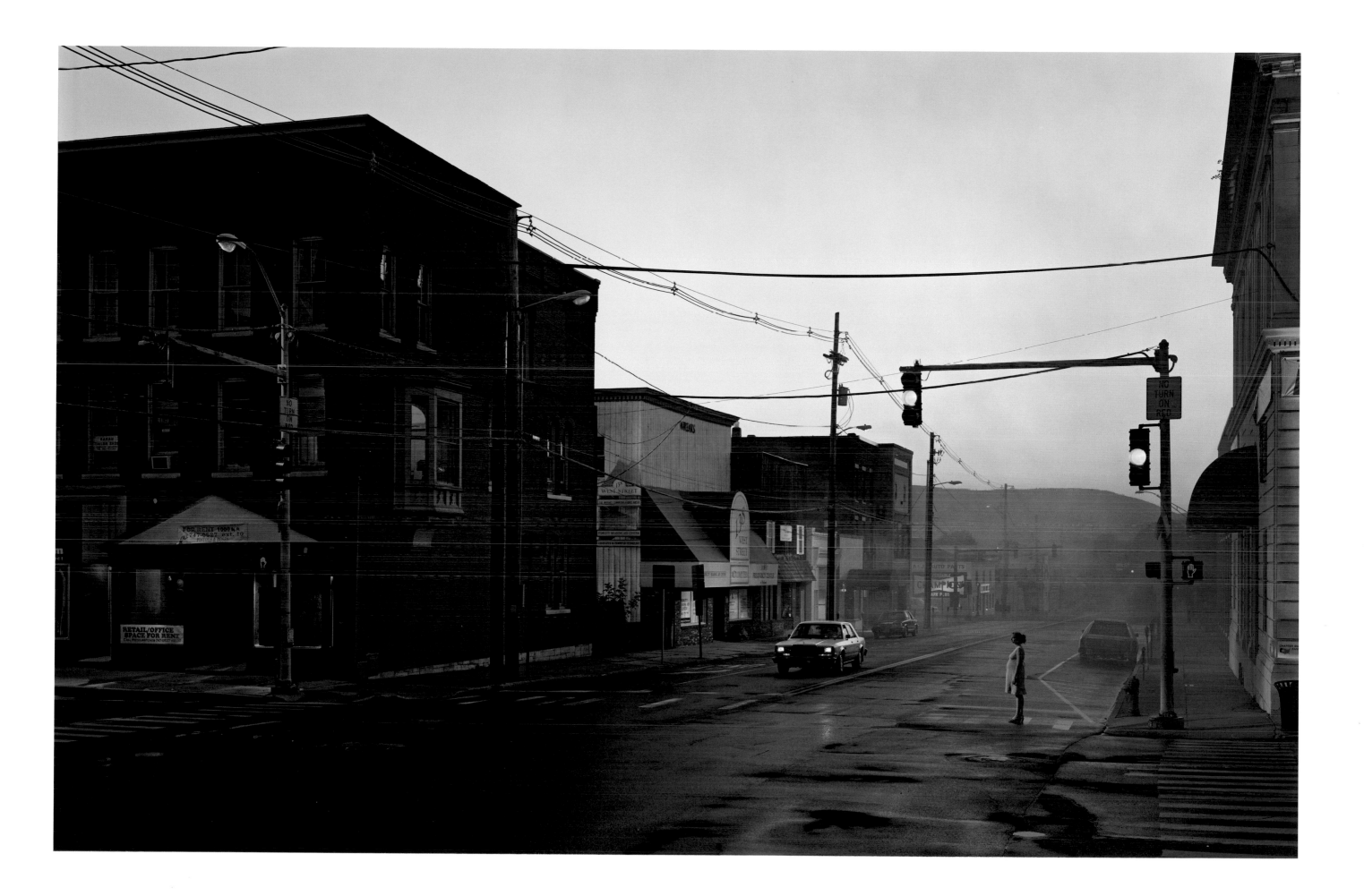

2.

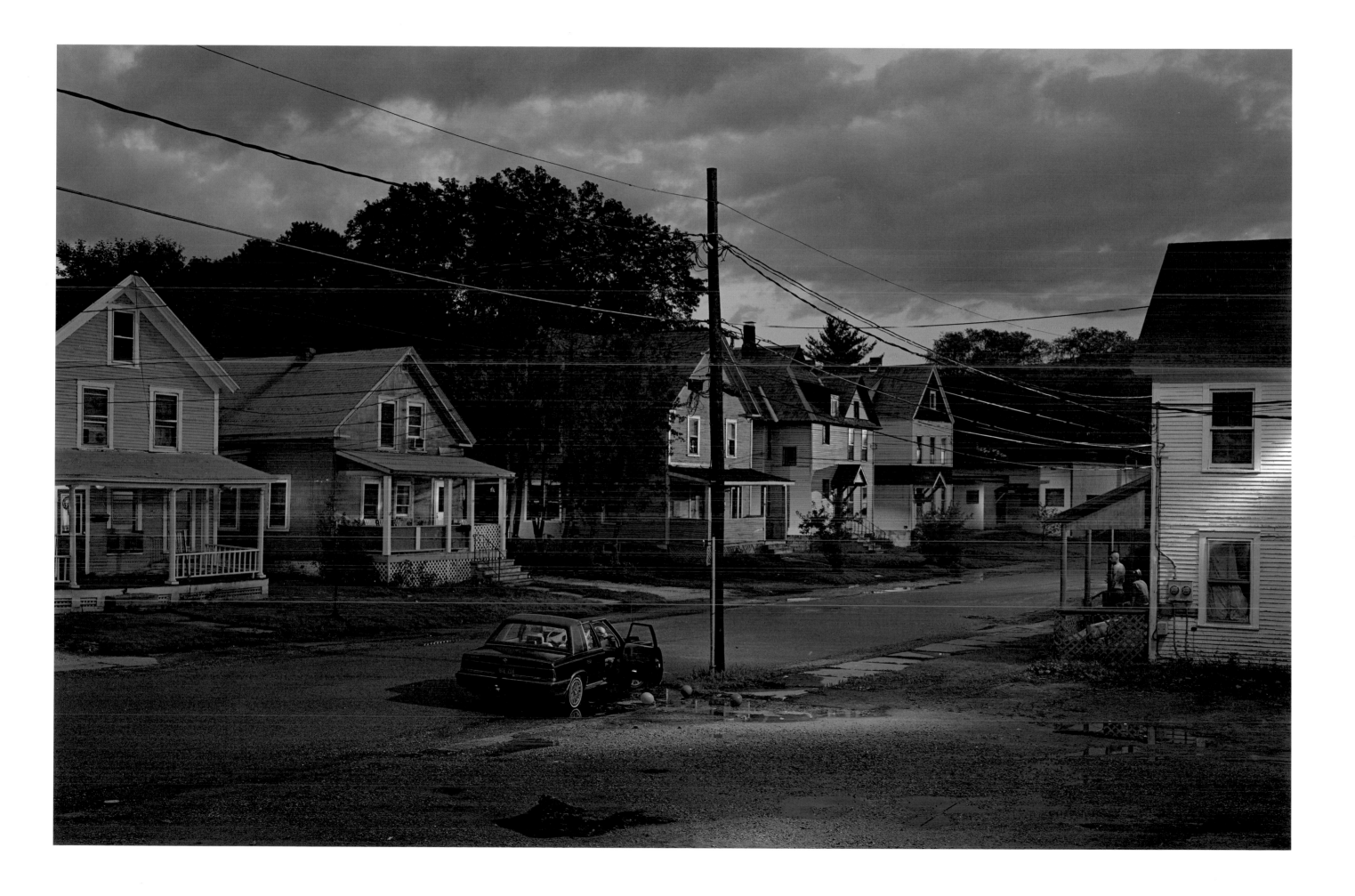

3.

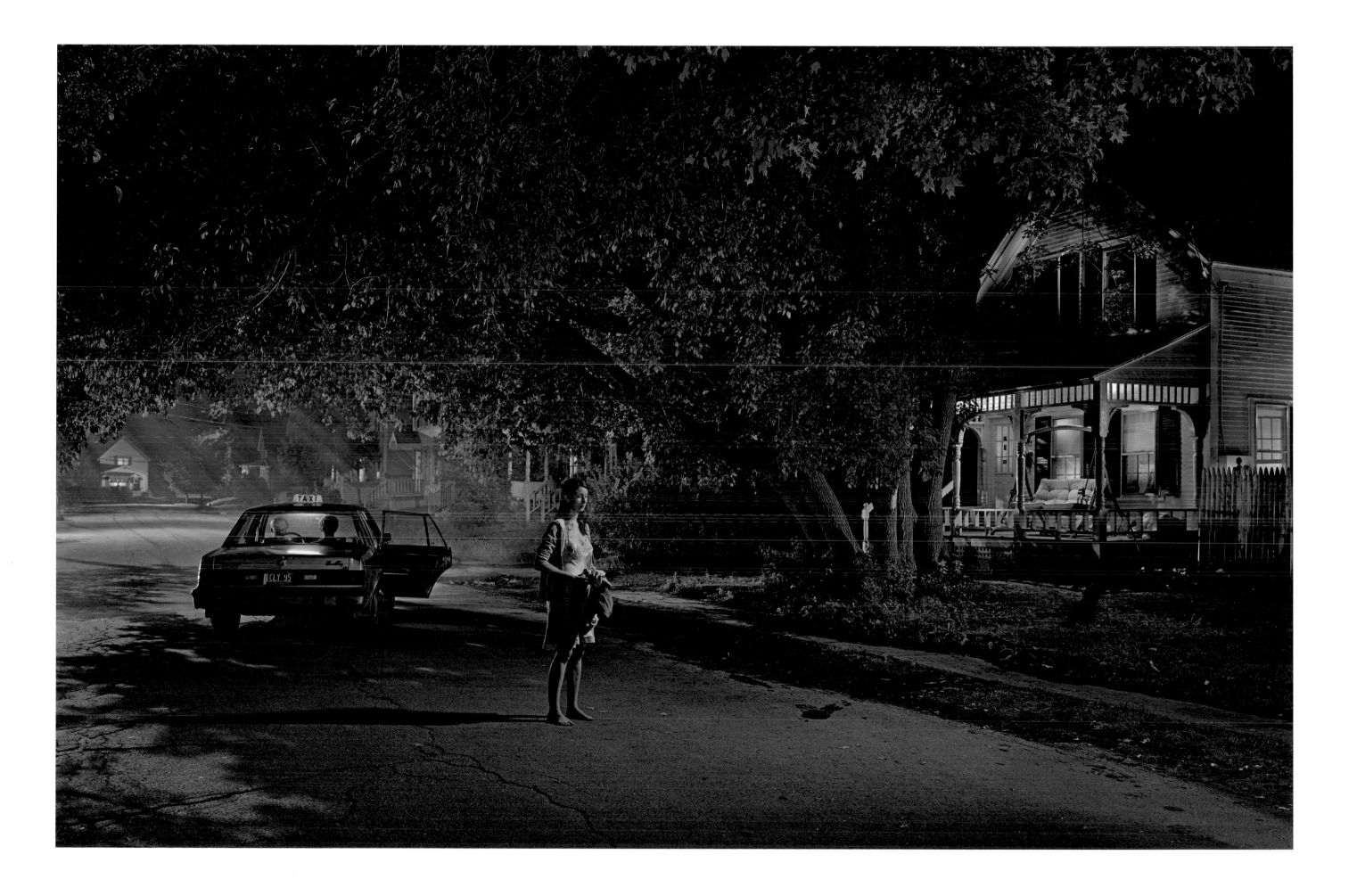

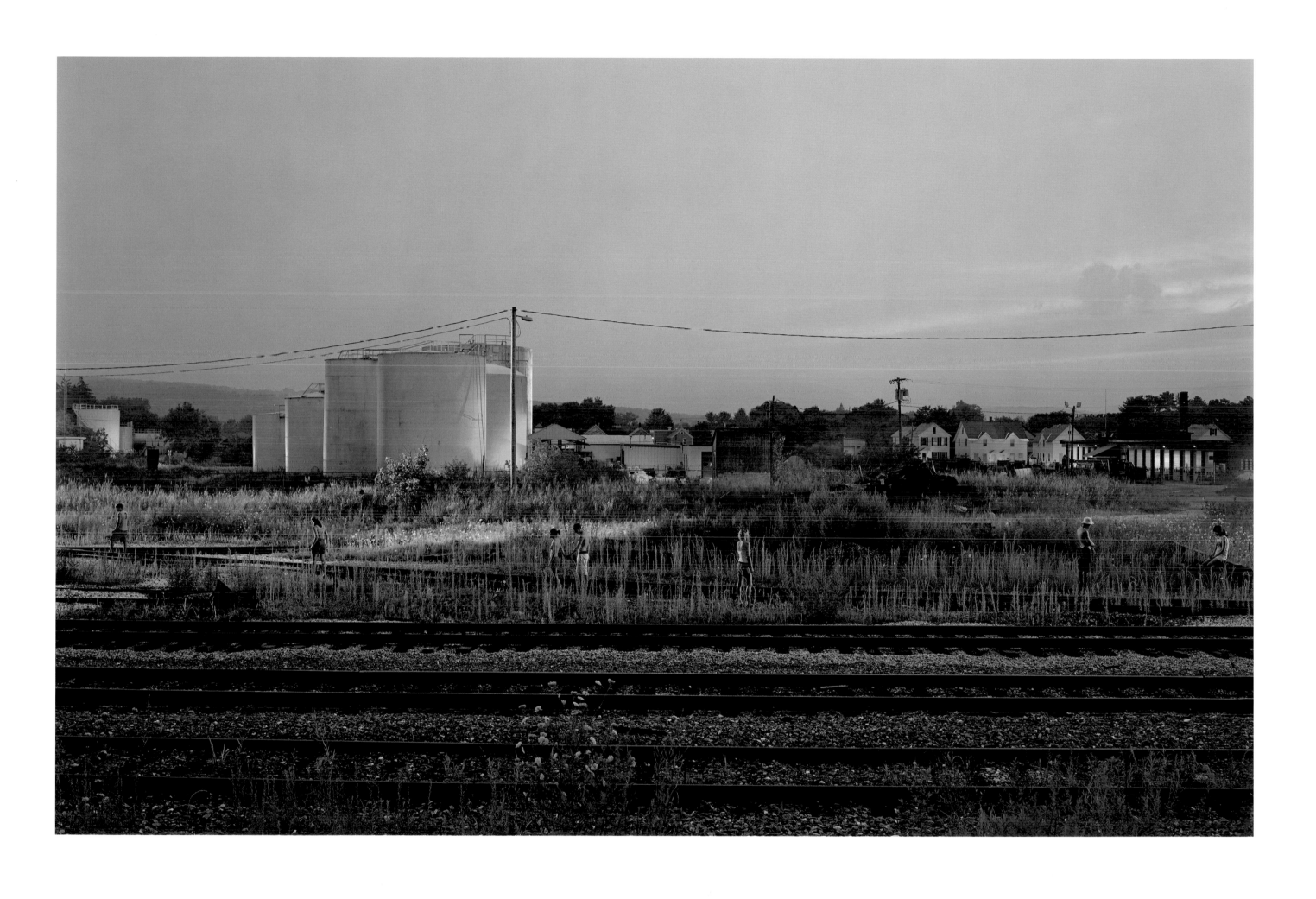

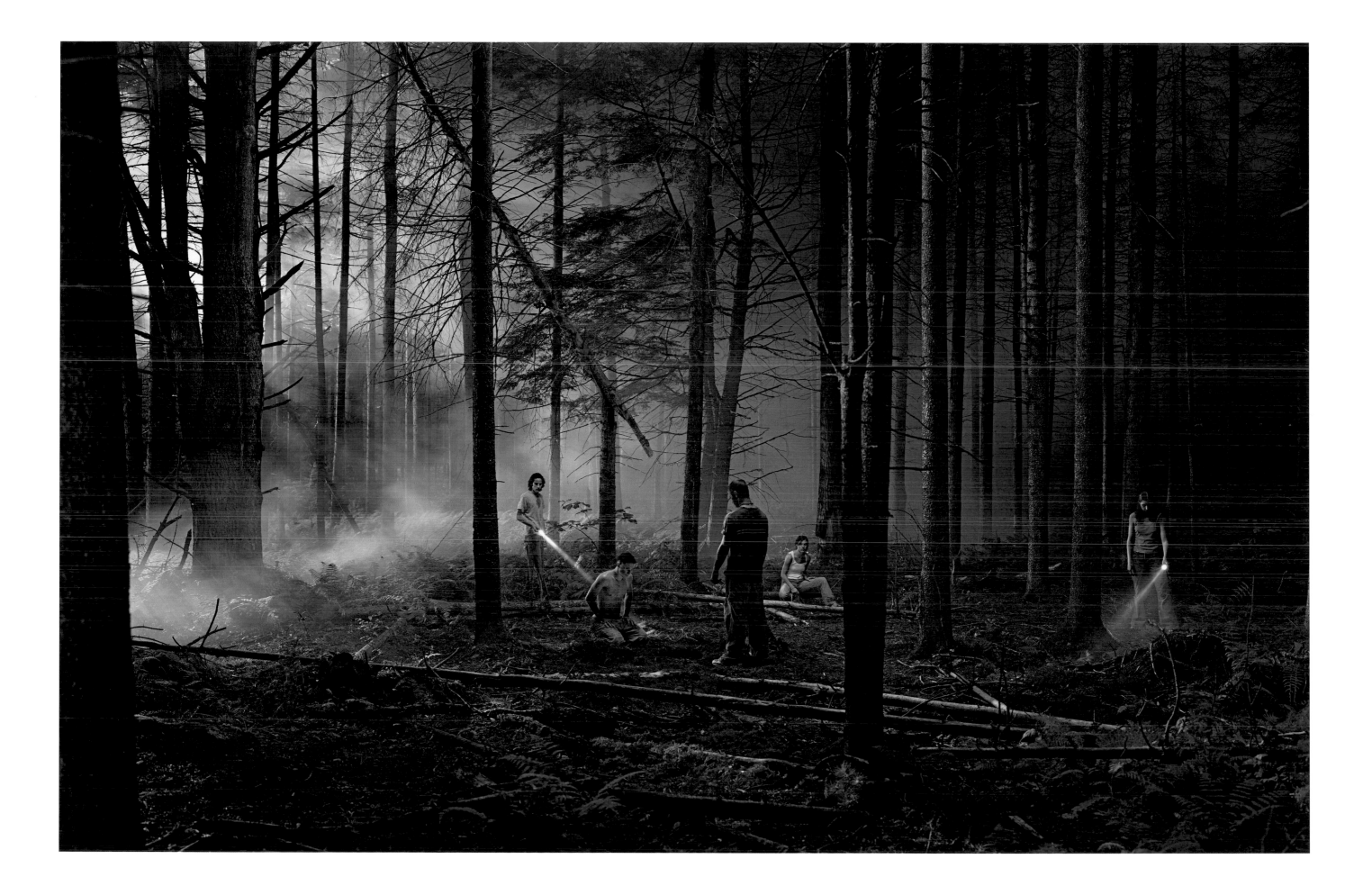

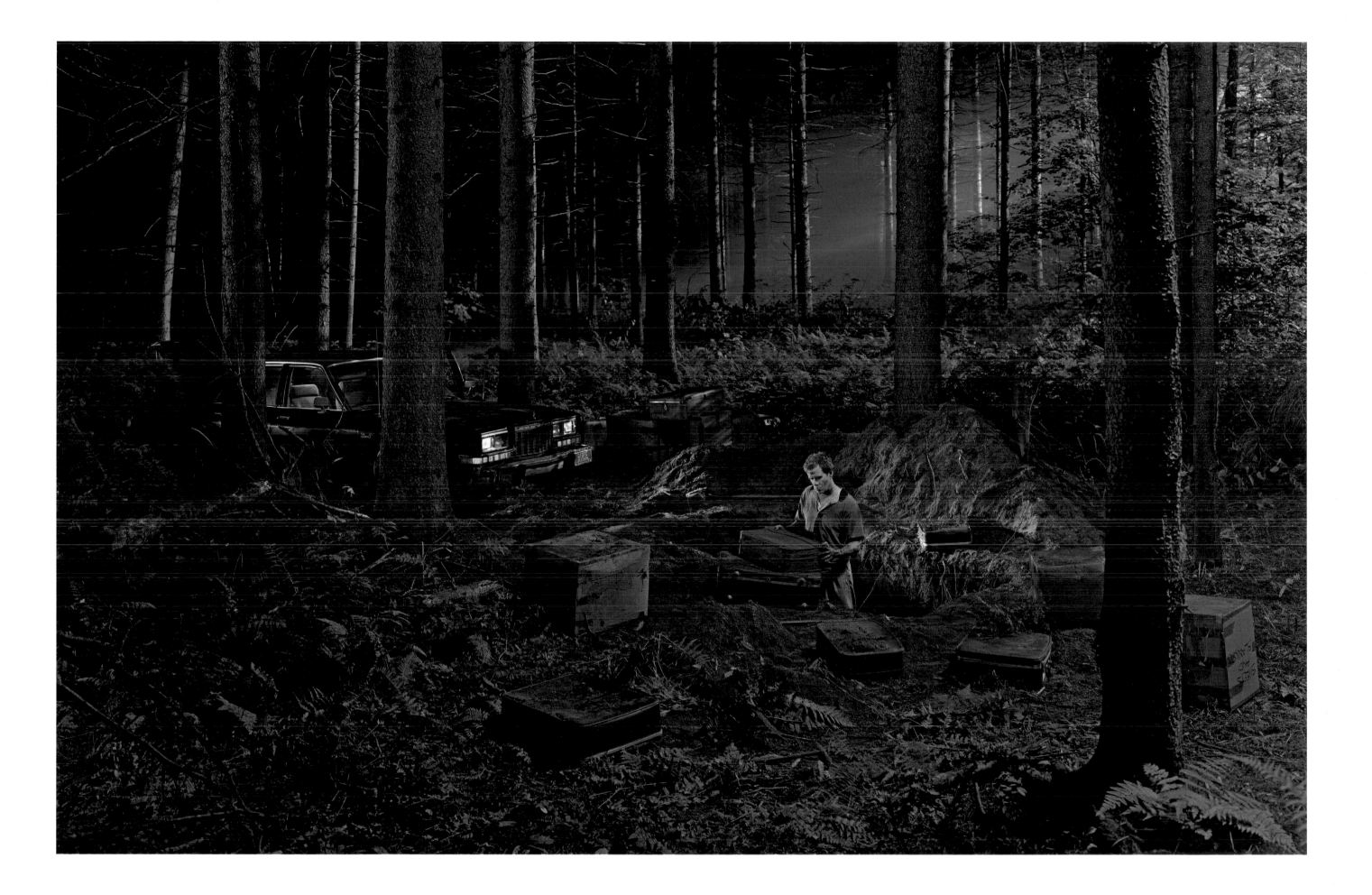

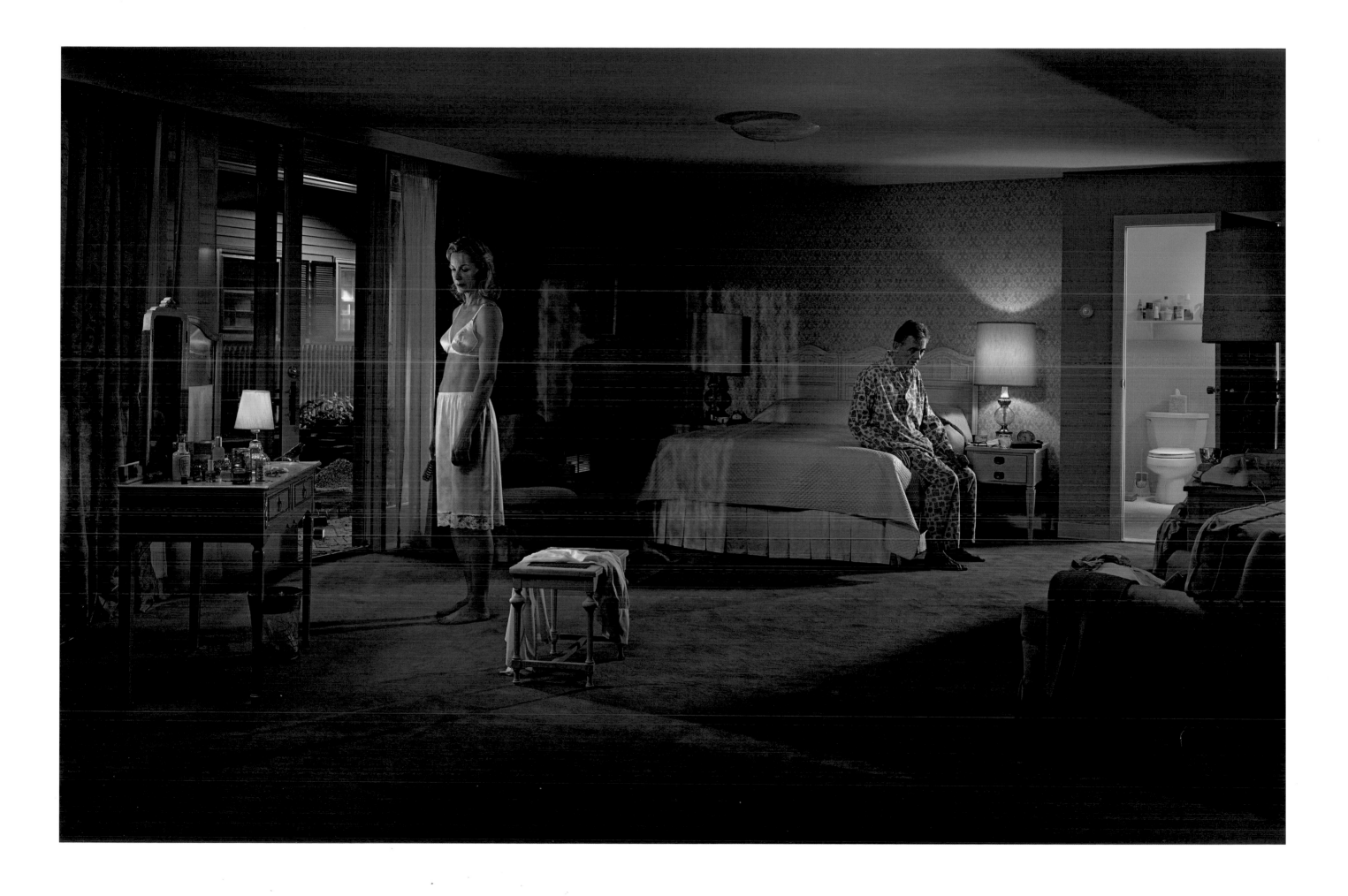

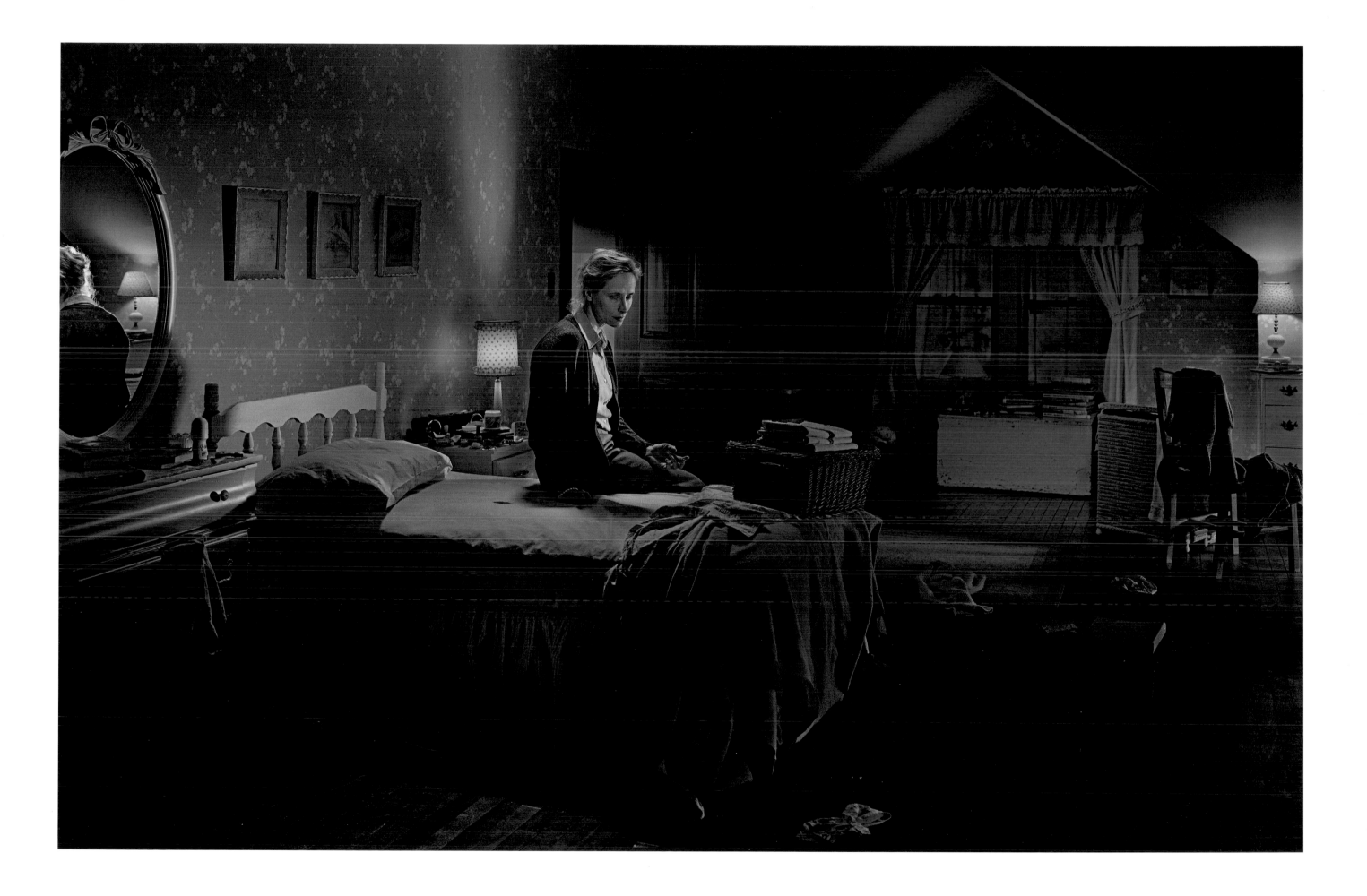

9.

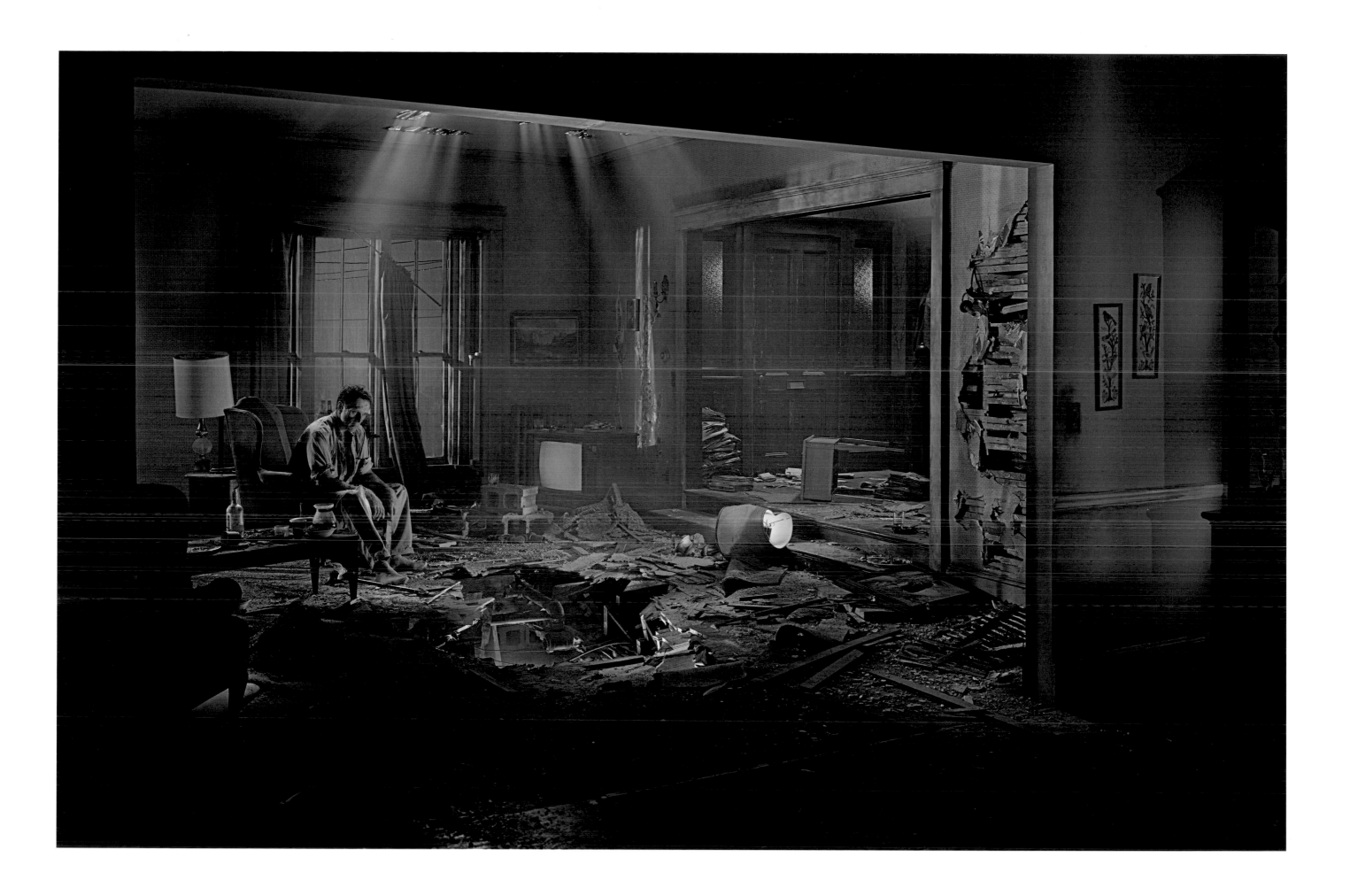

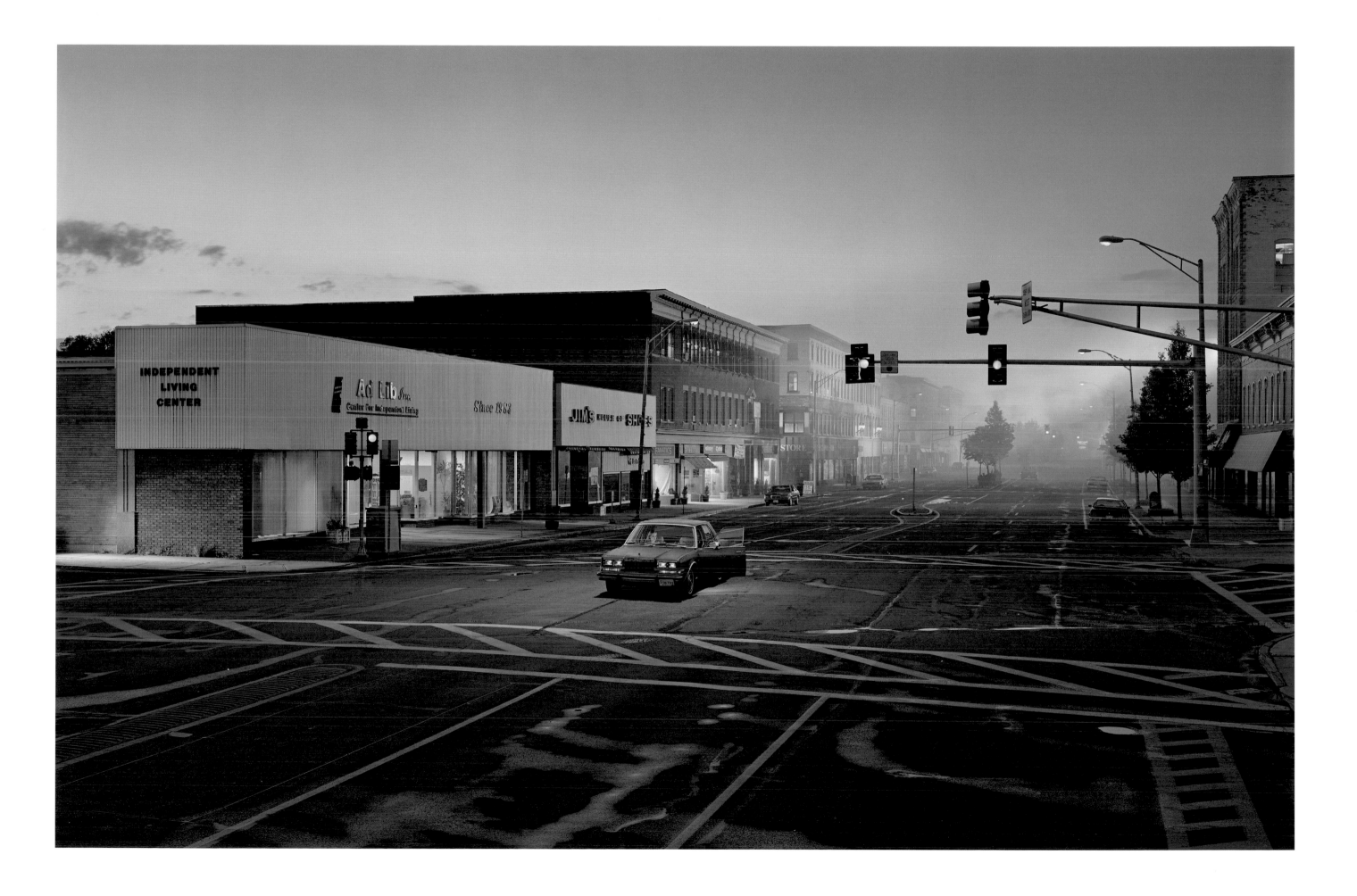

II.

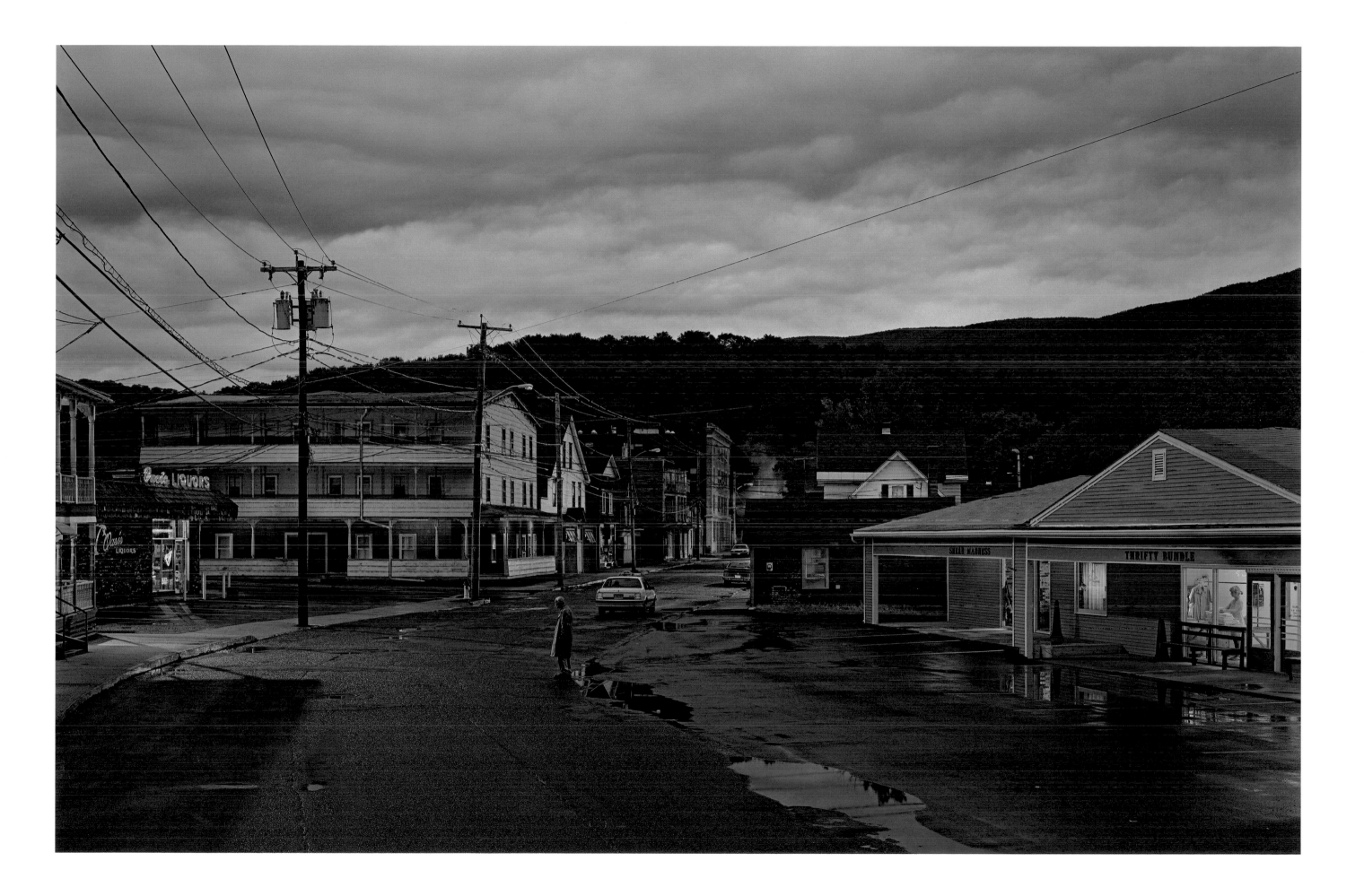

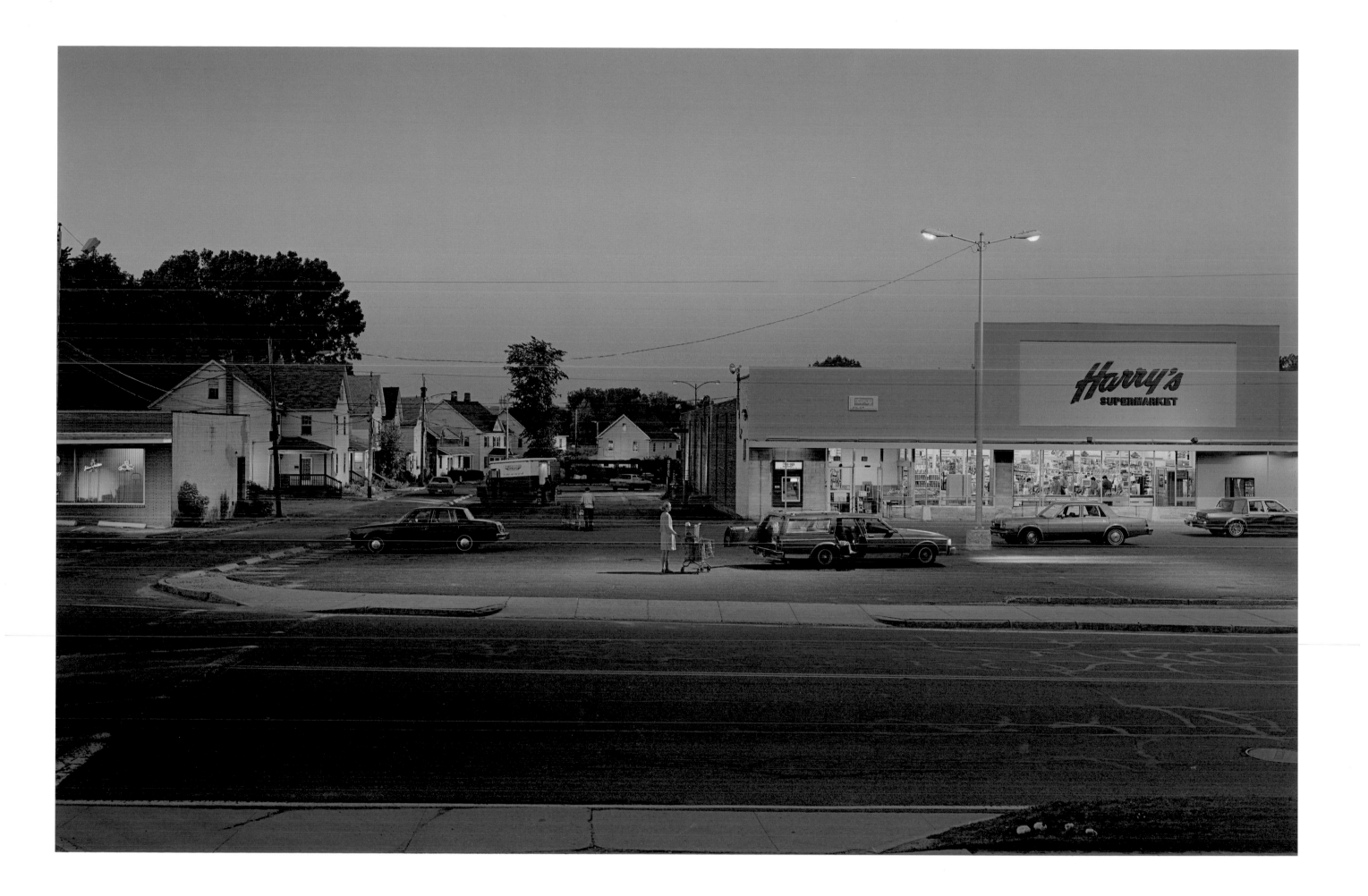

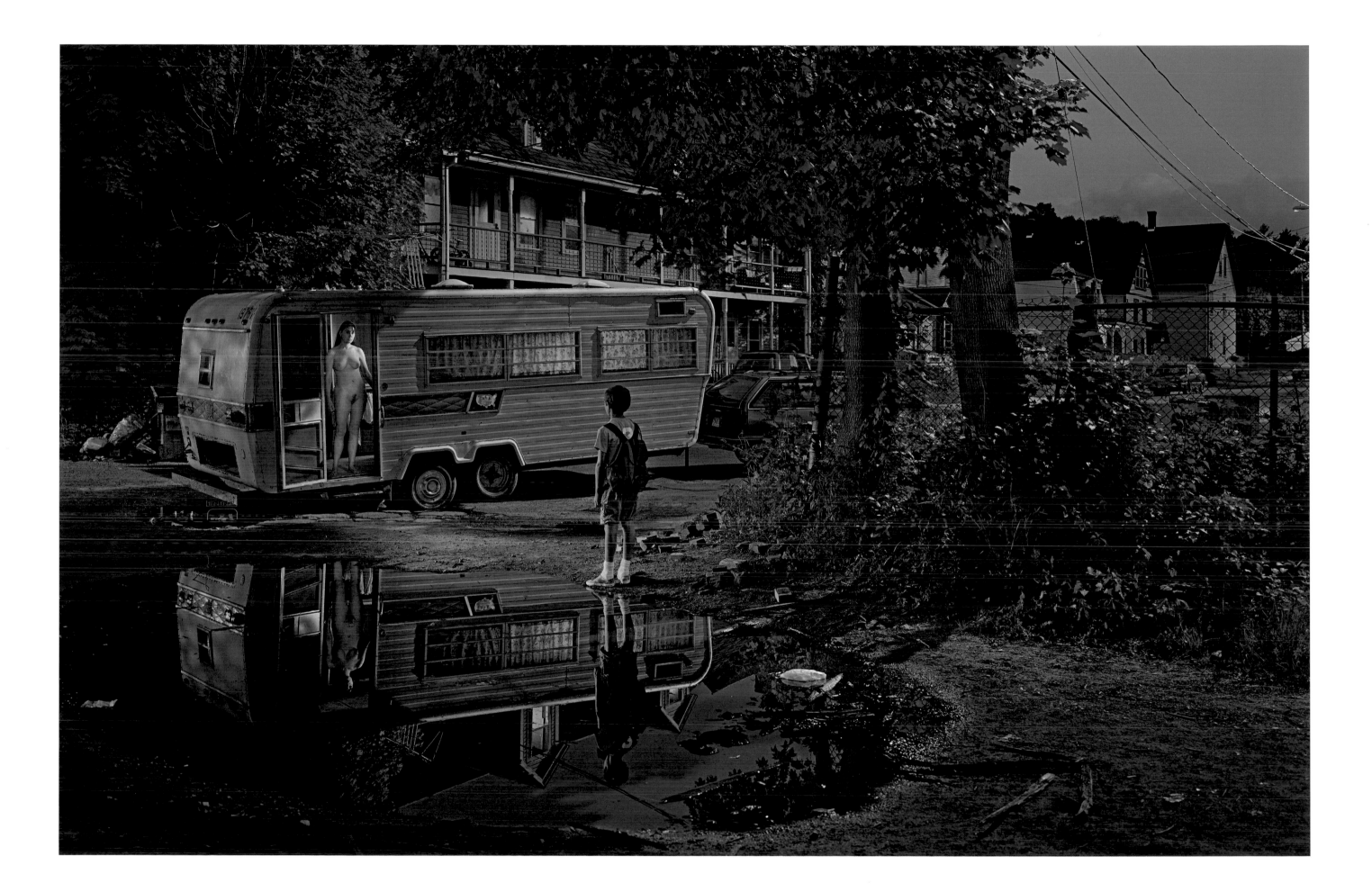

14.

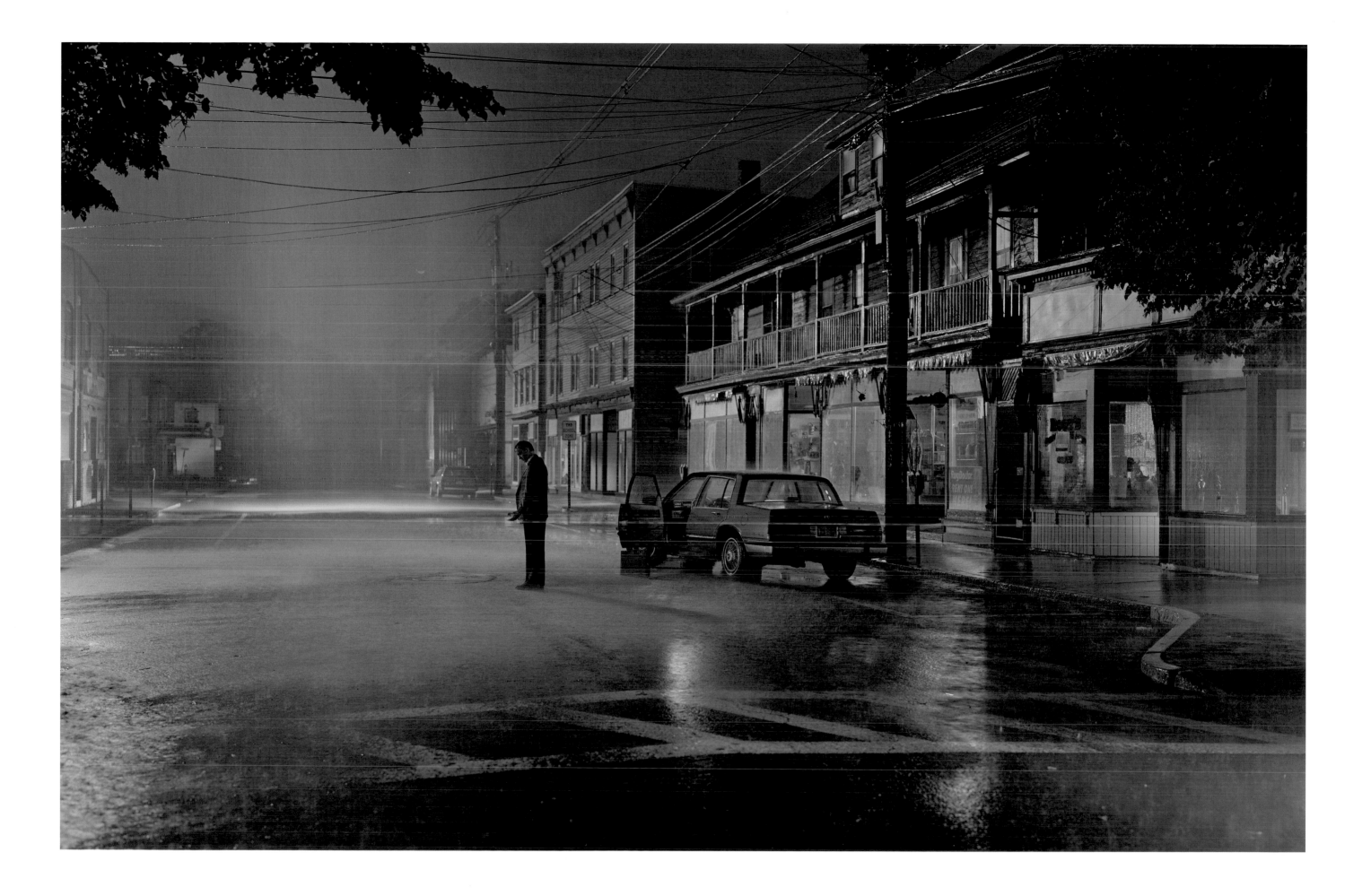

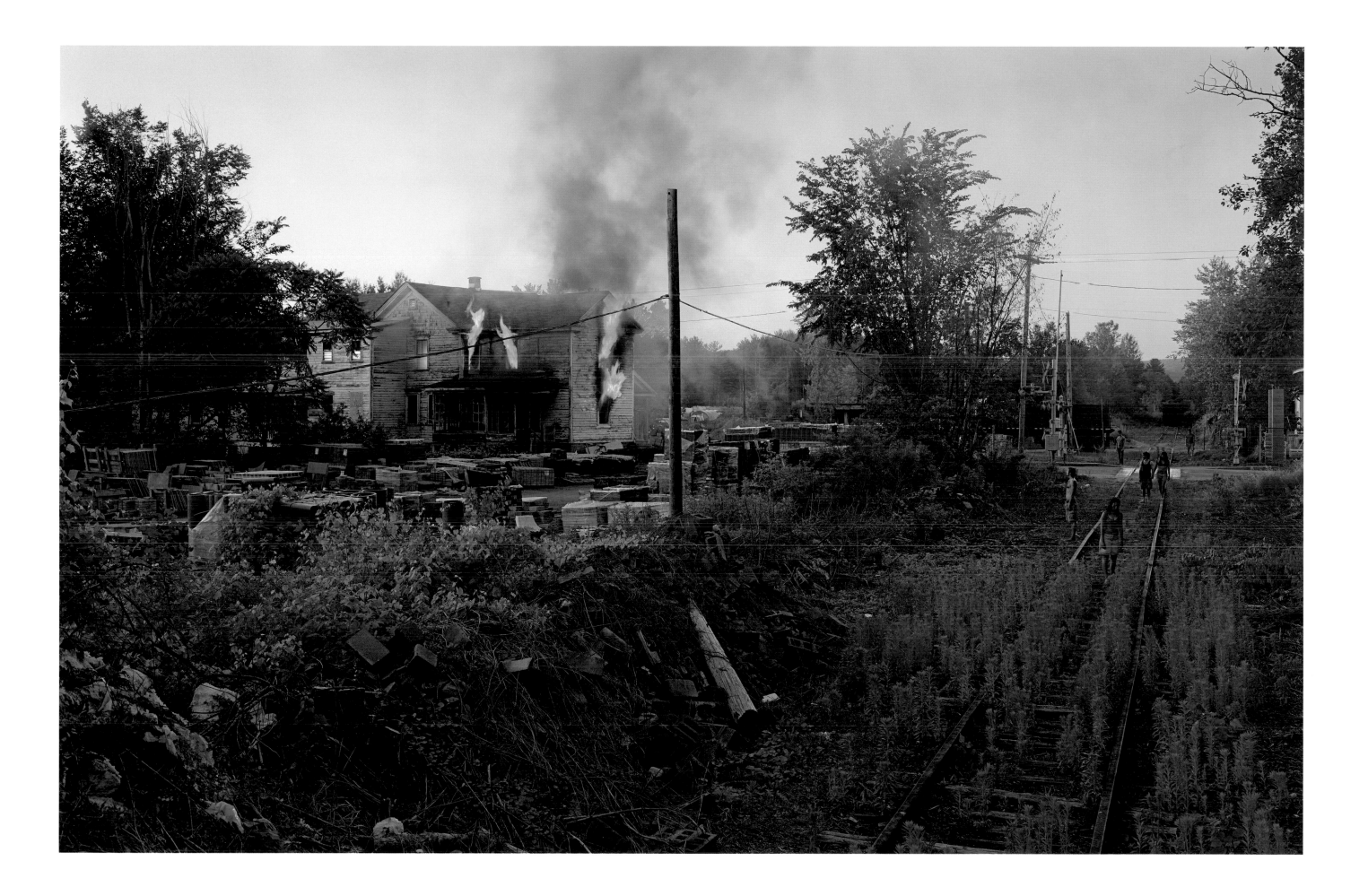

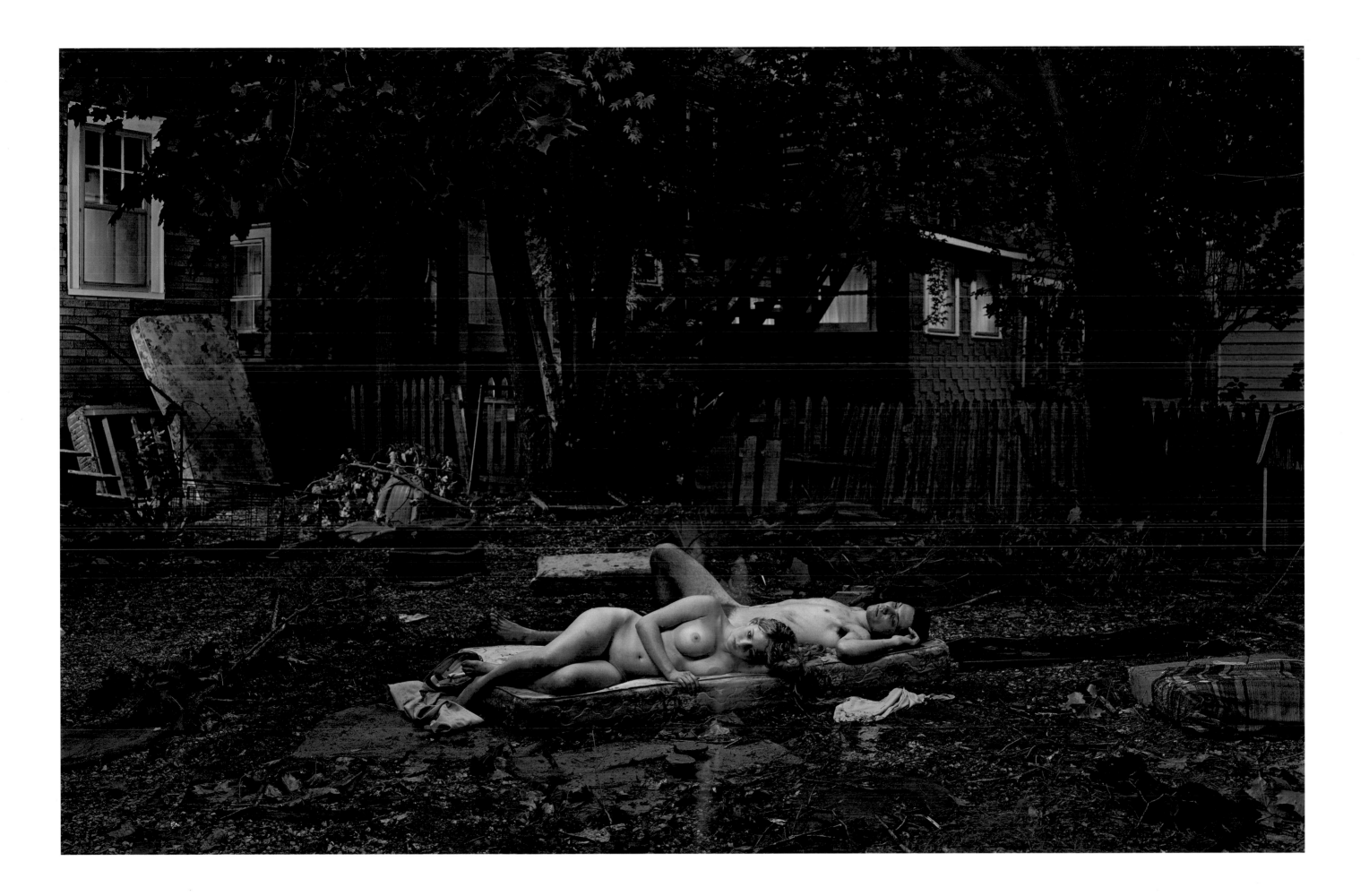

17.

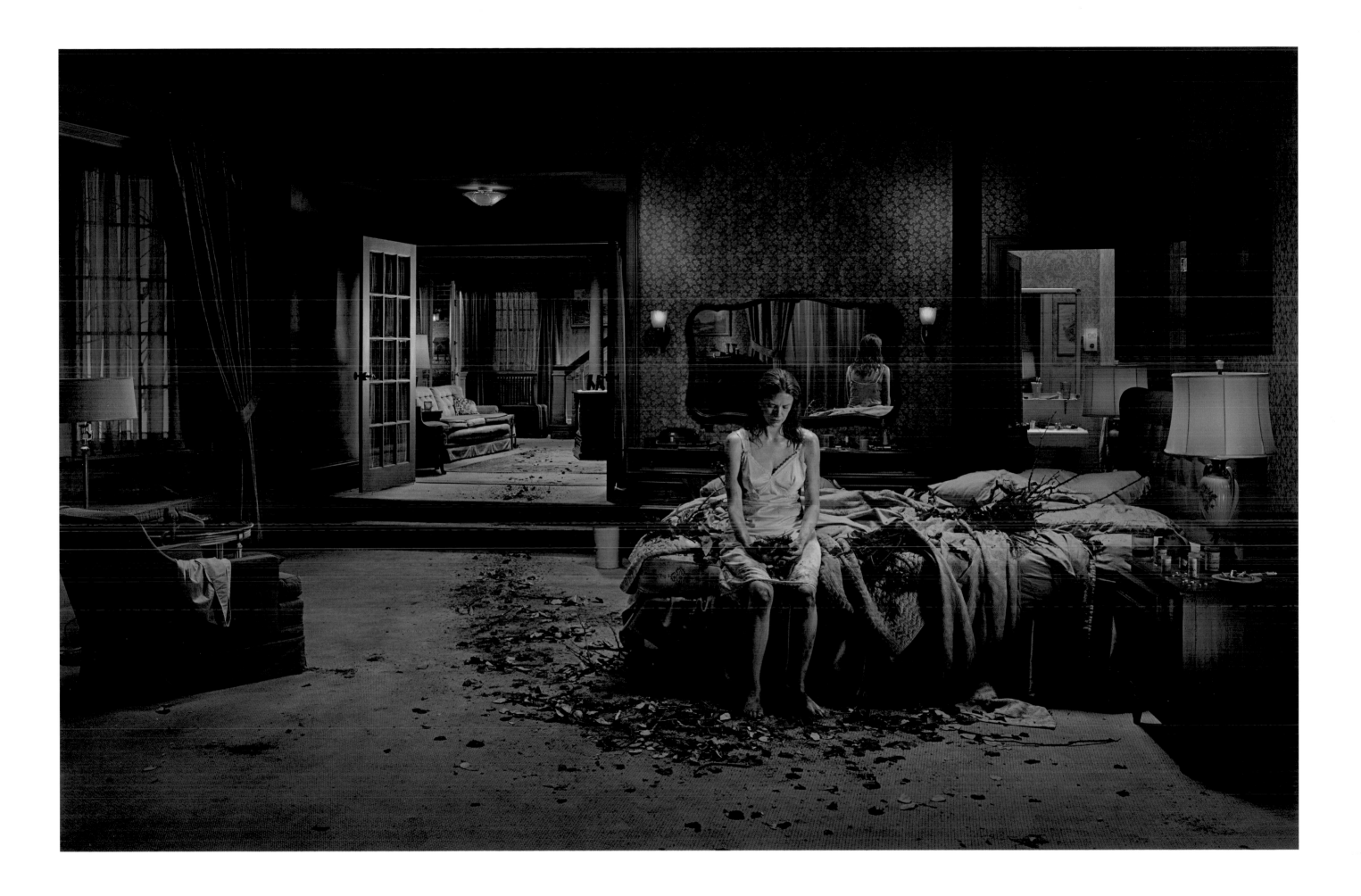

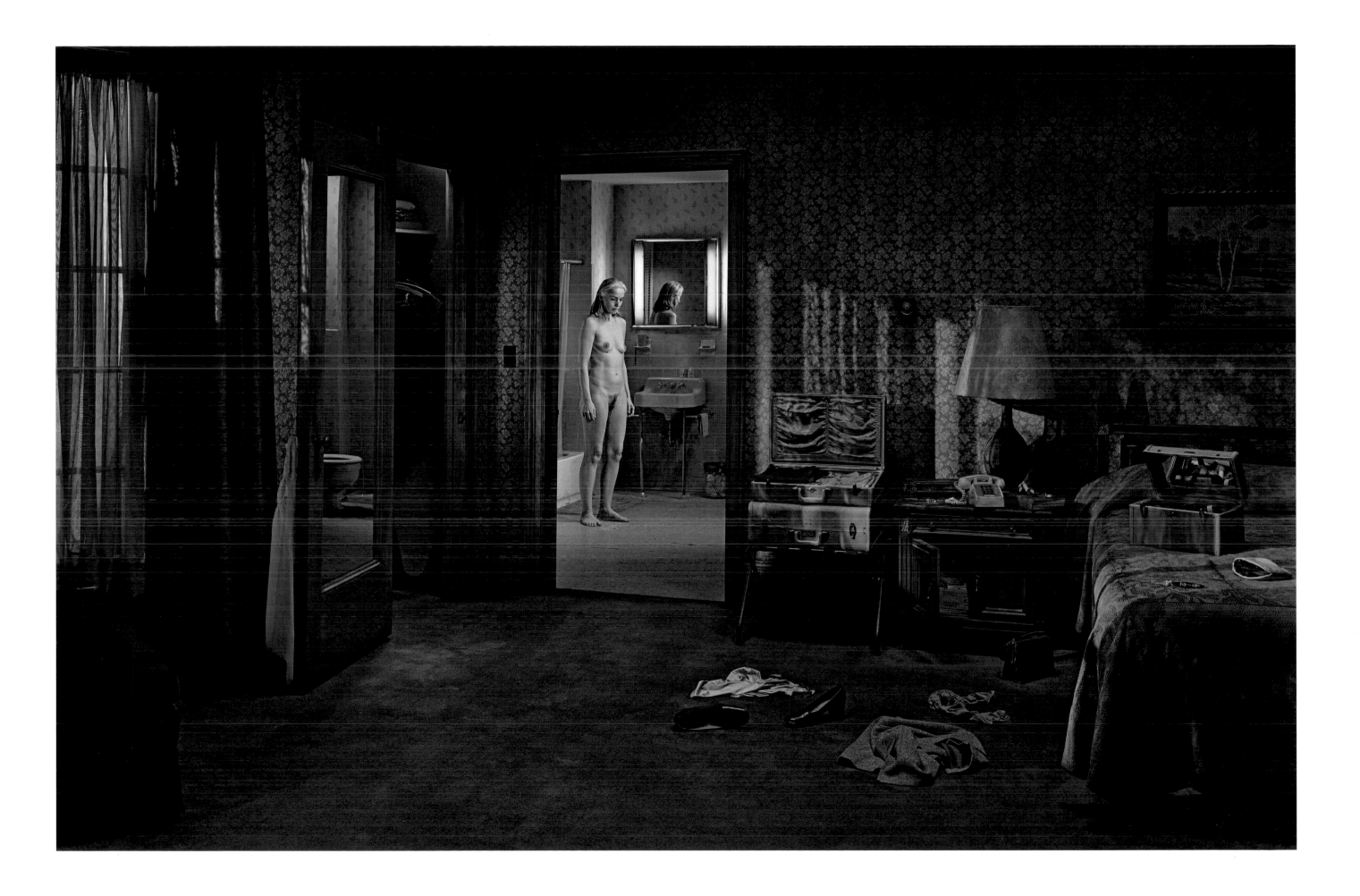

19.

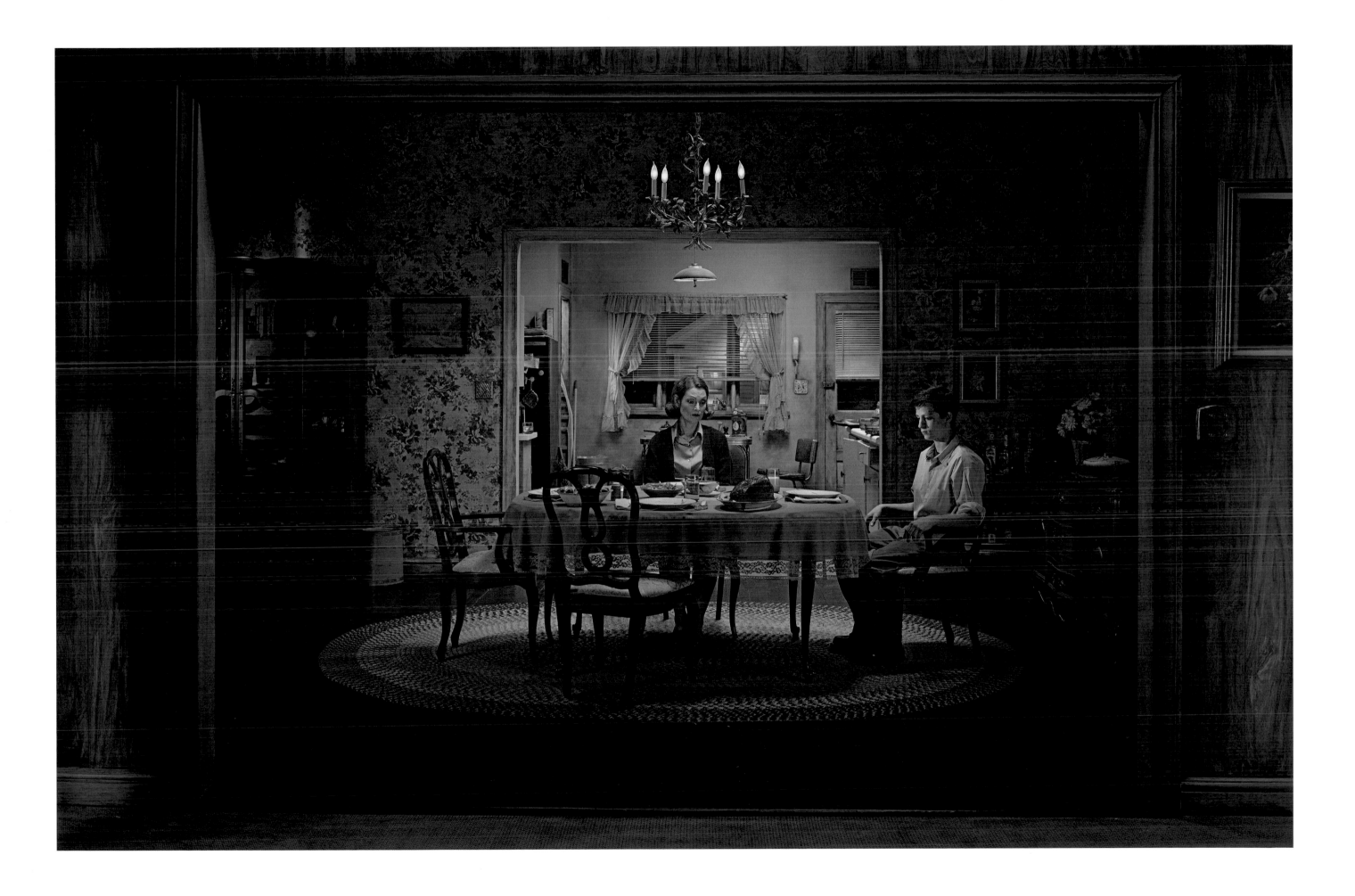

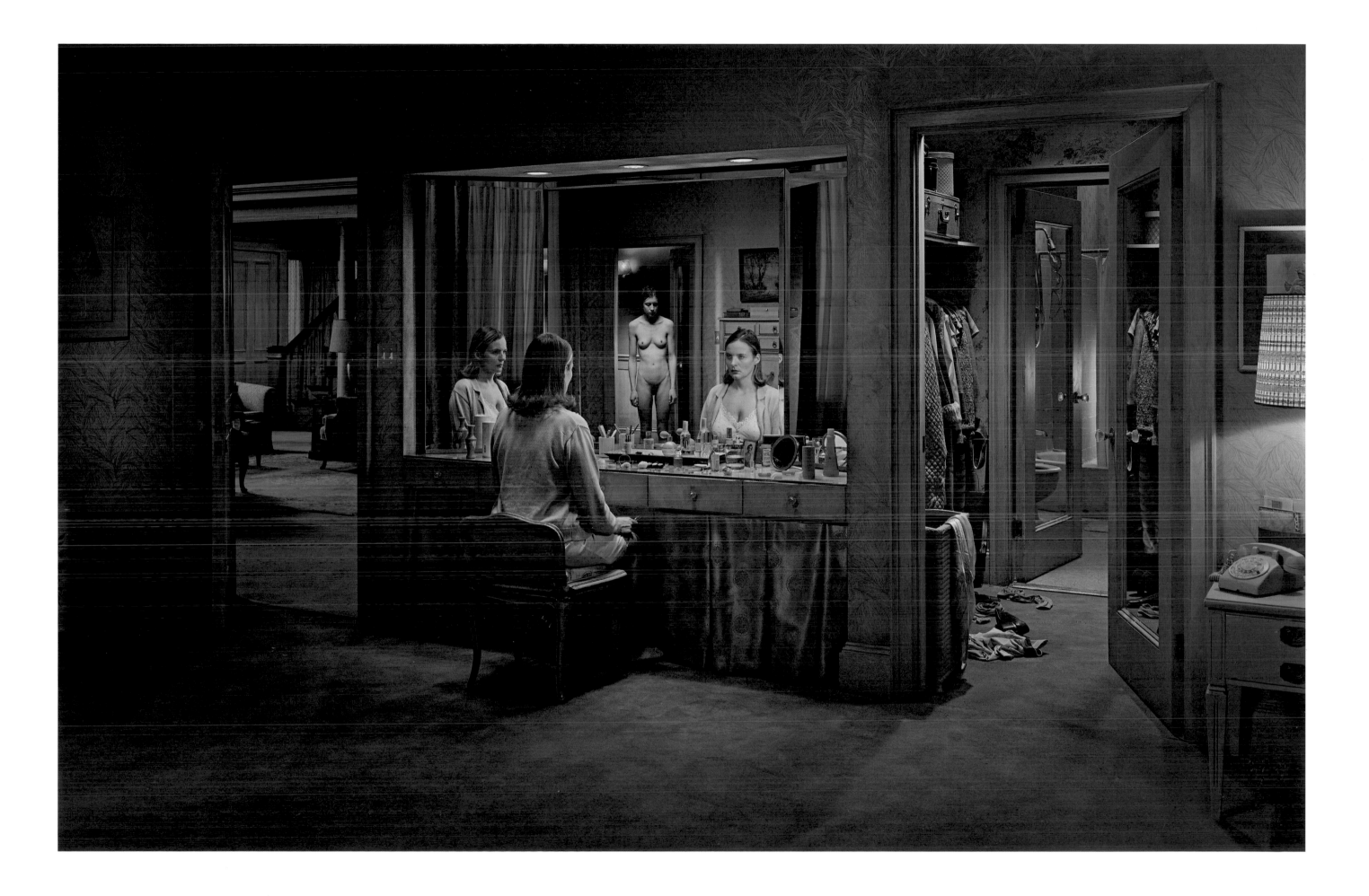

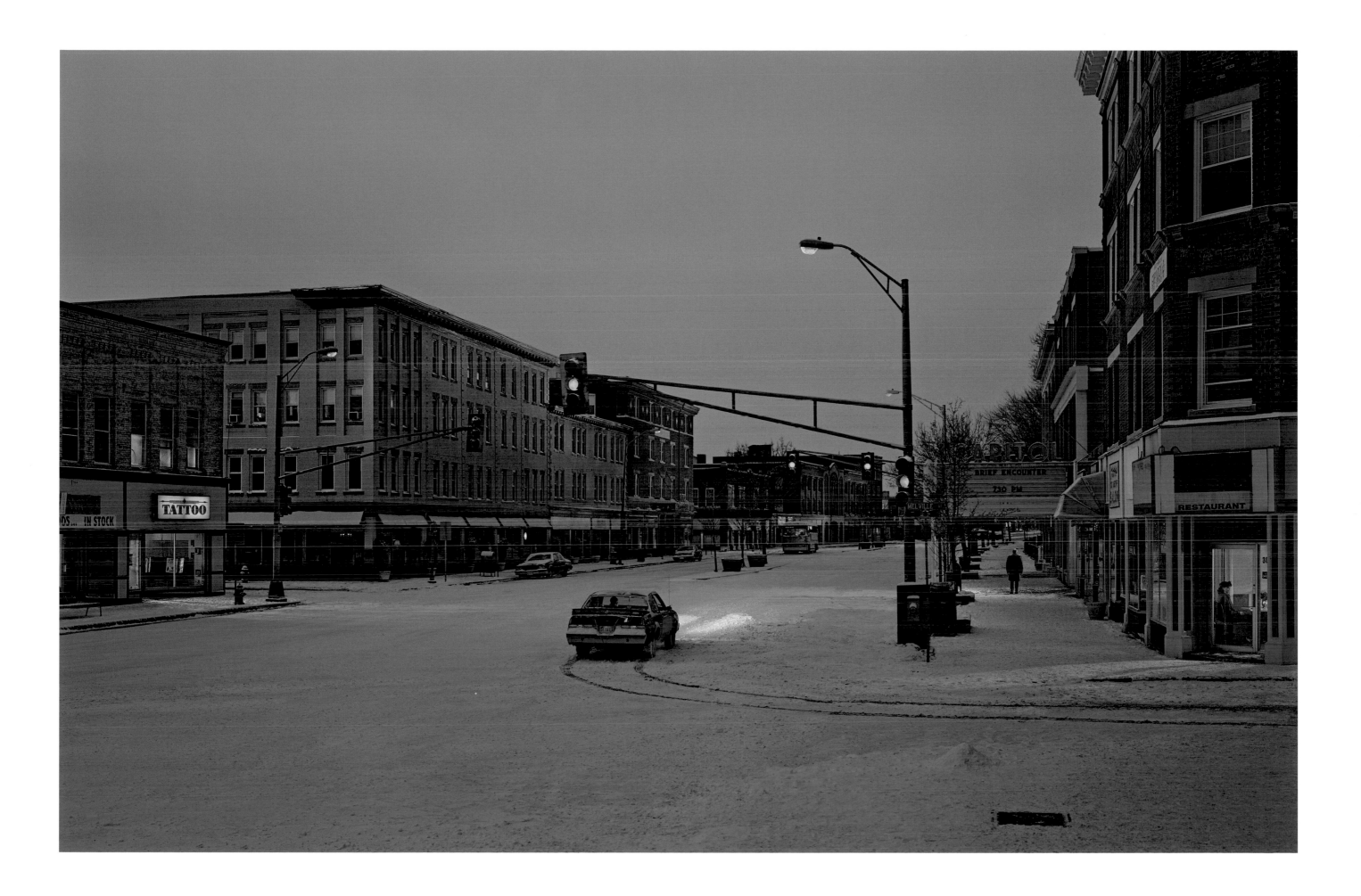

22.

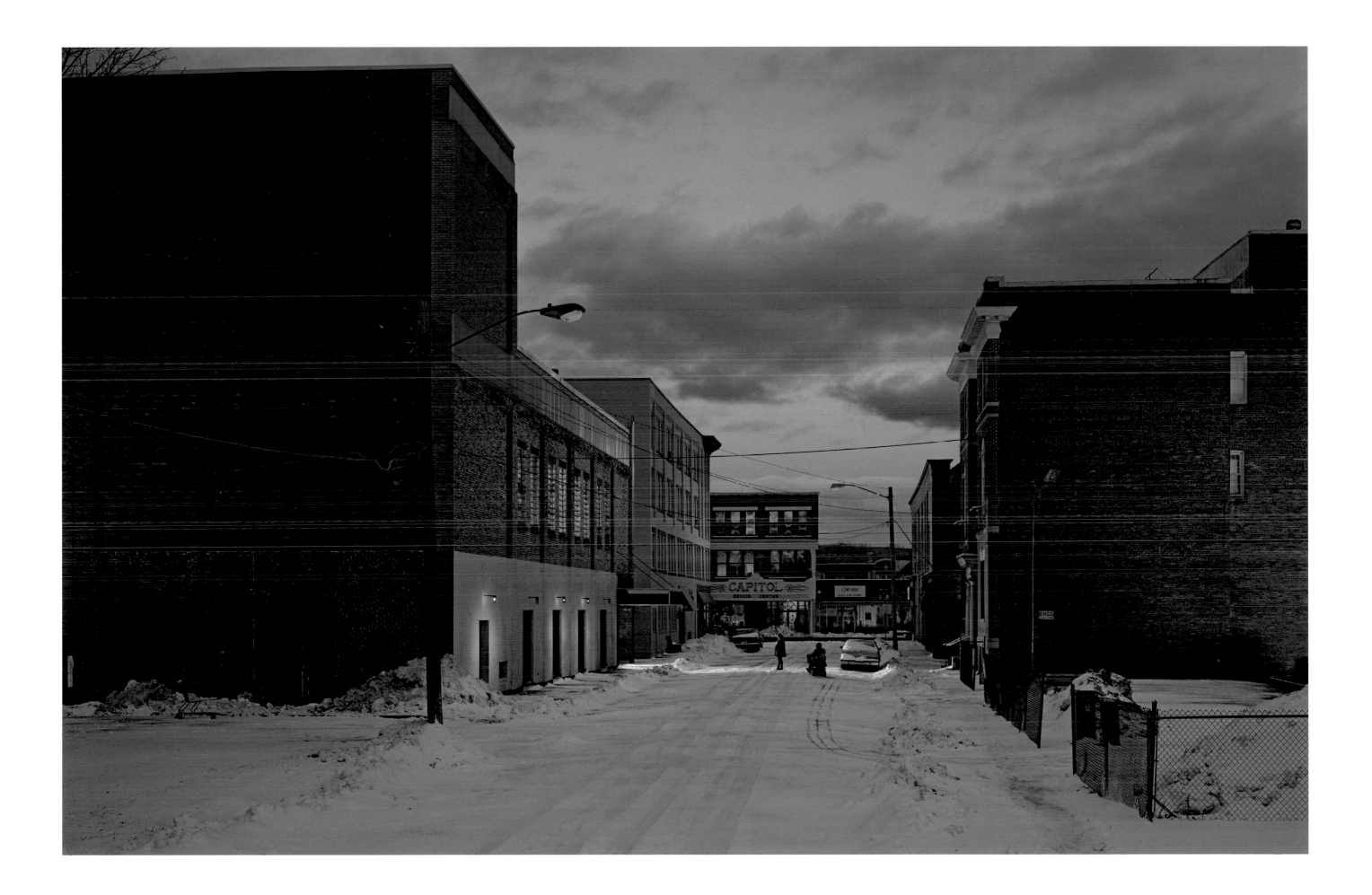

23.

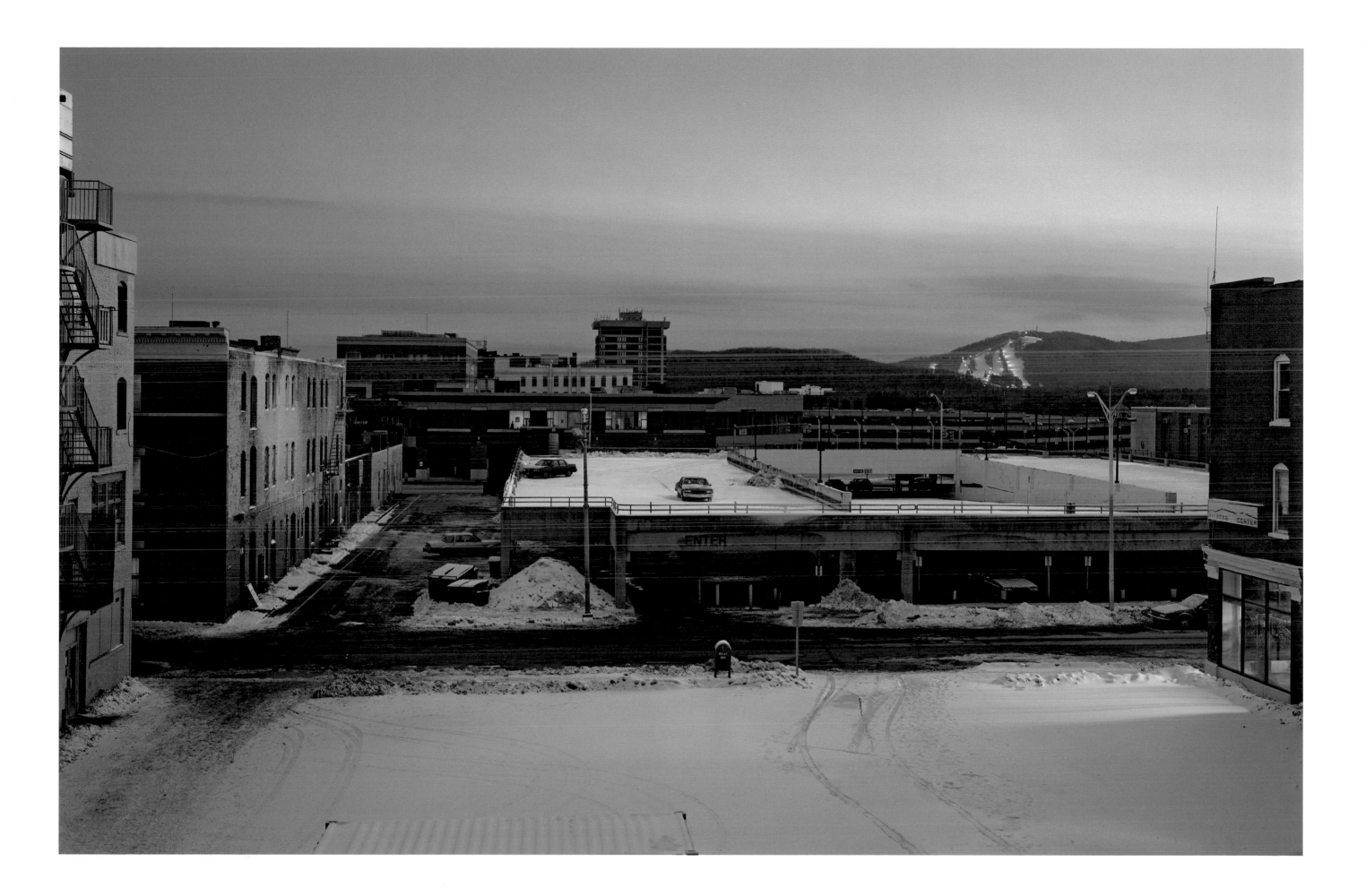

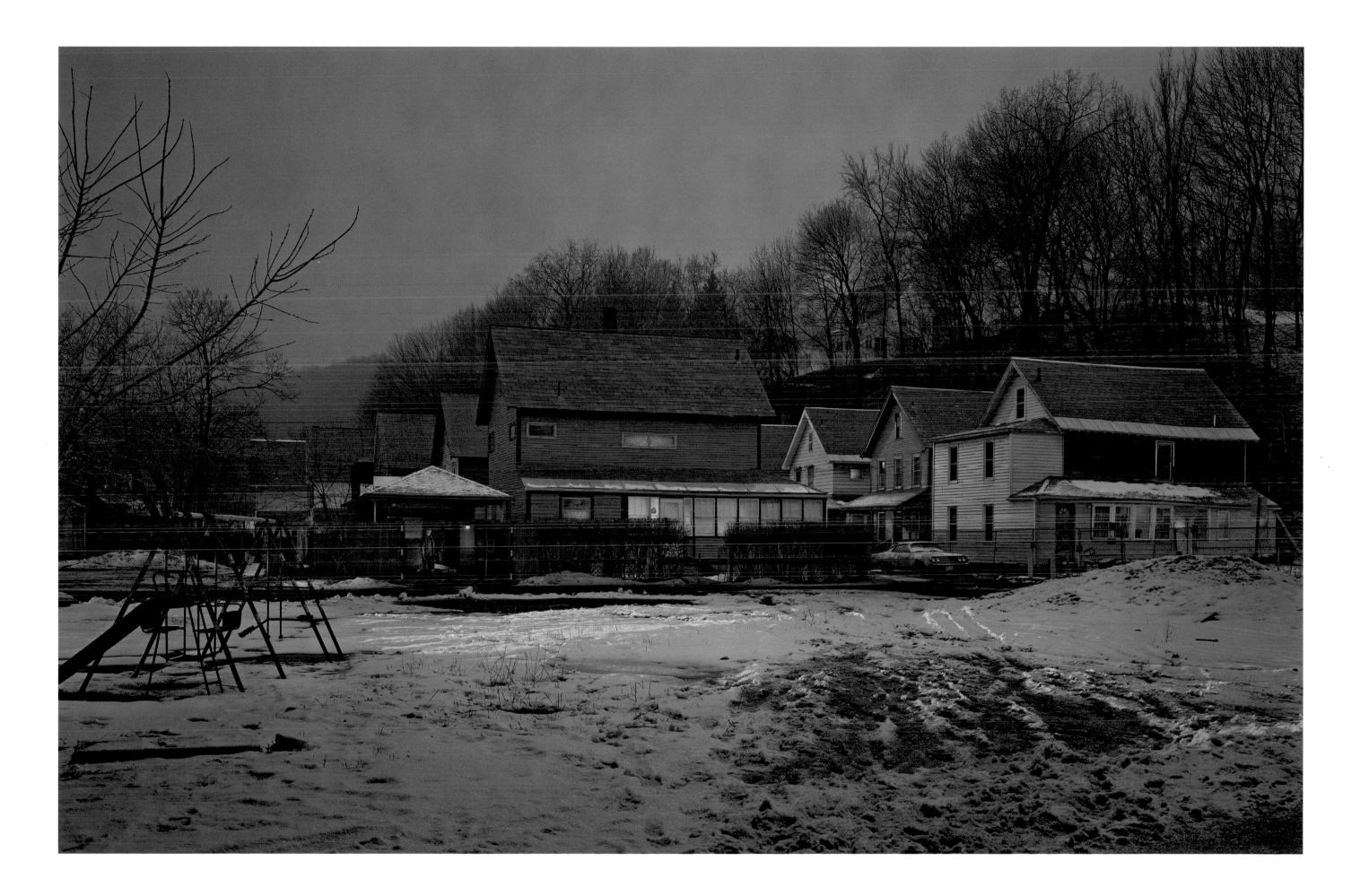

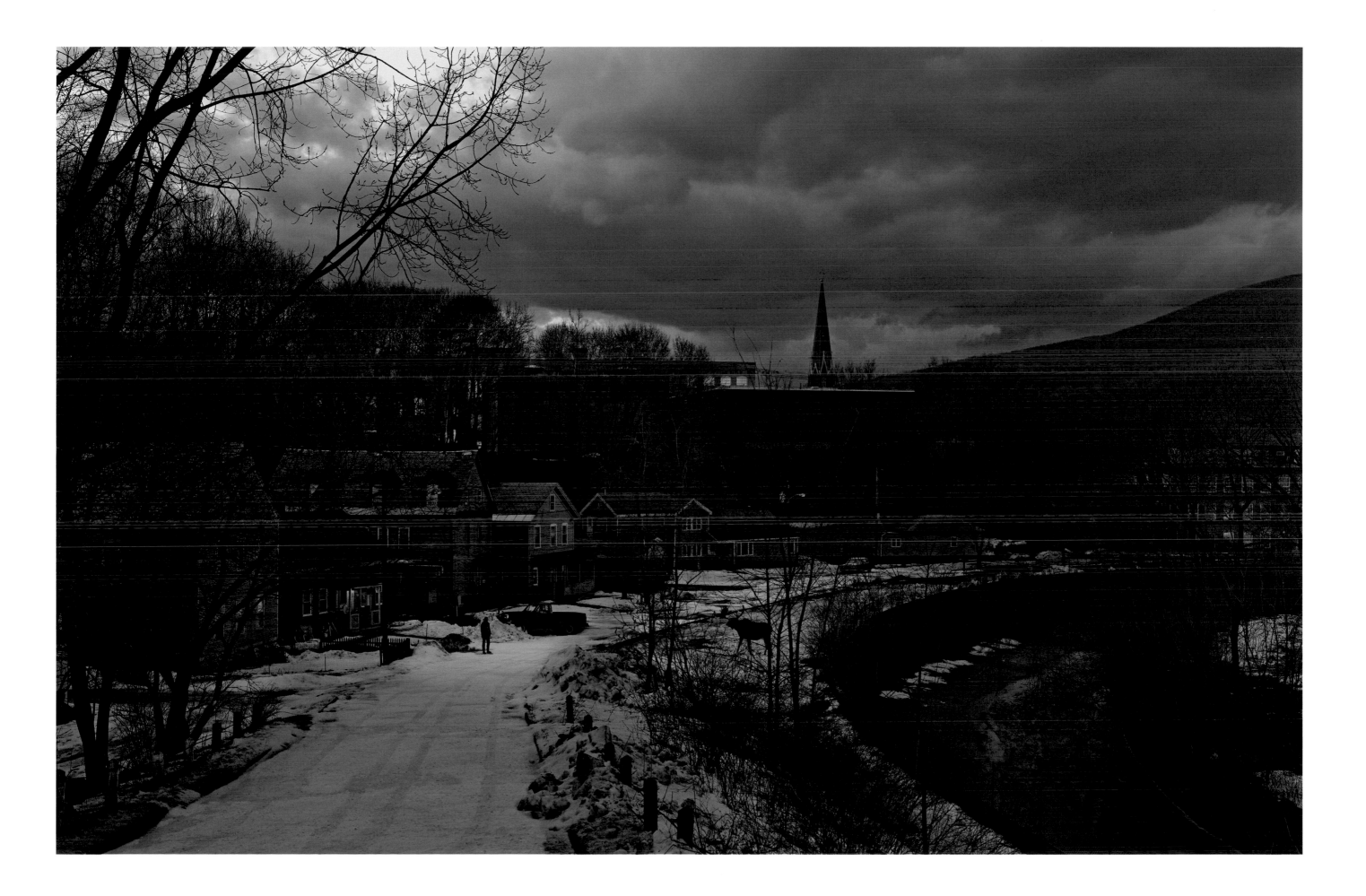

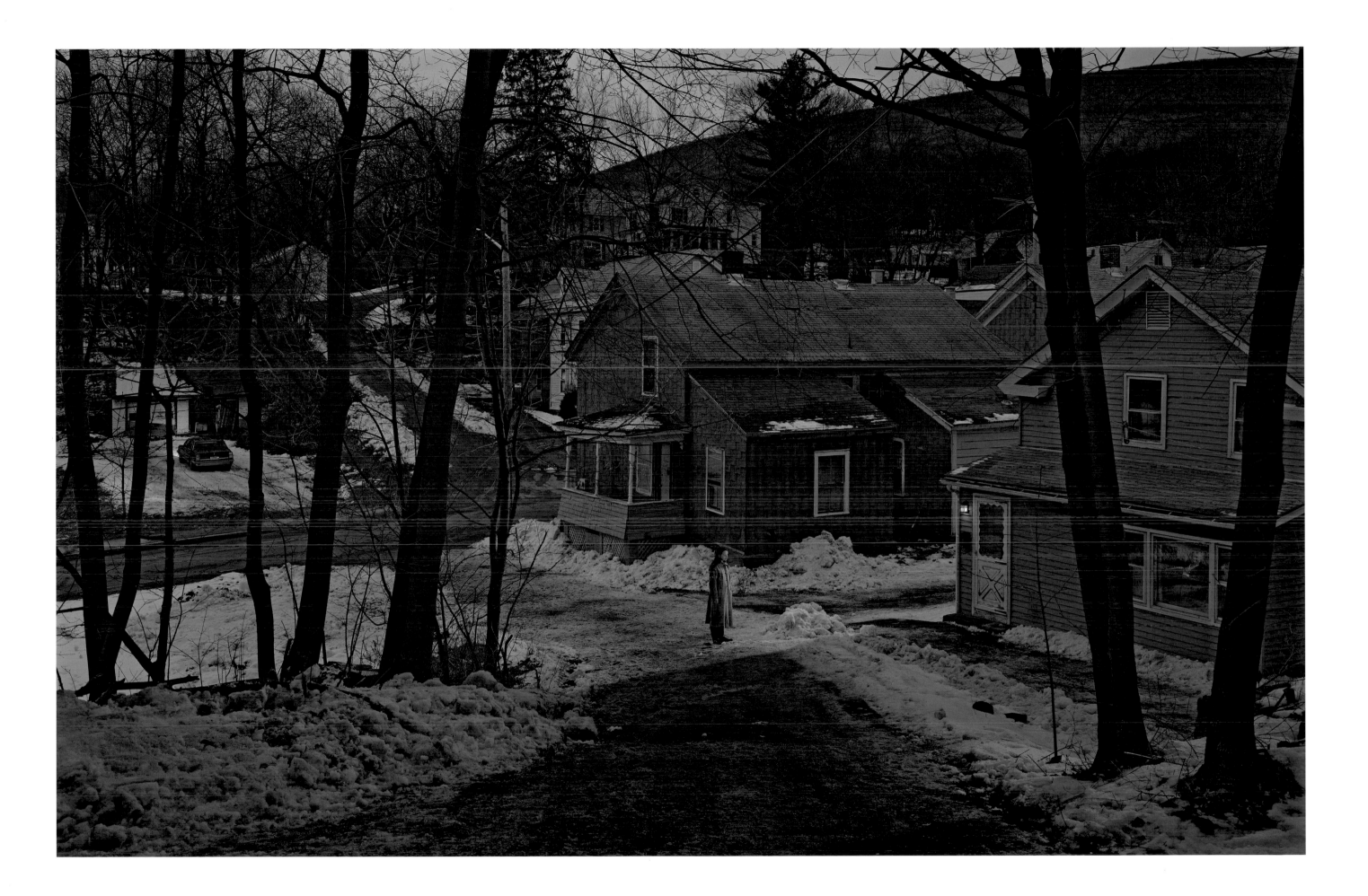

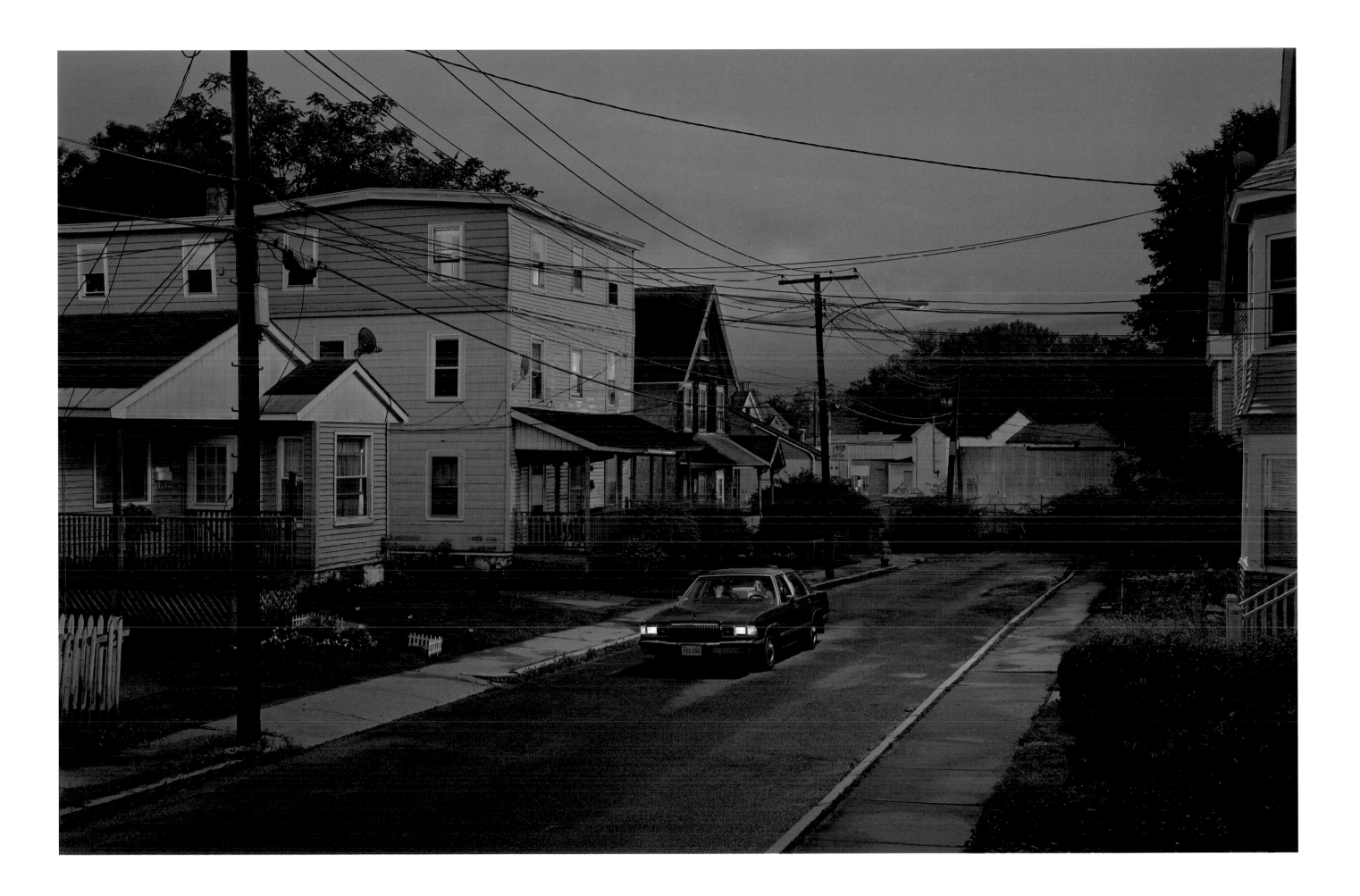

28.

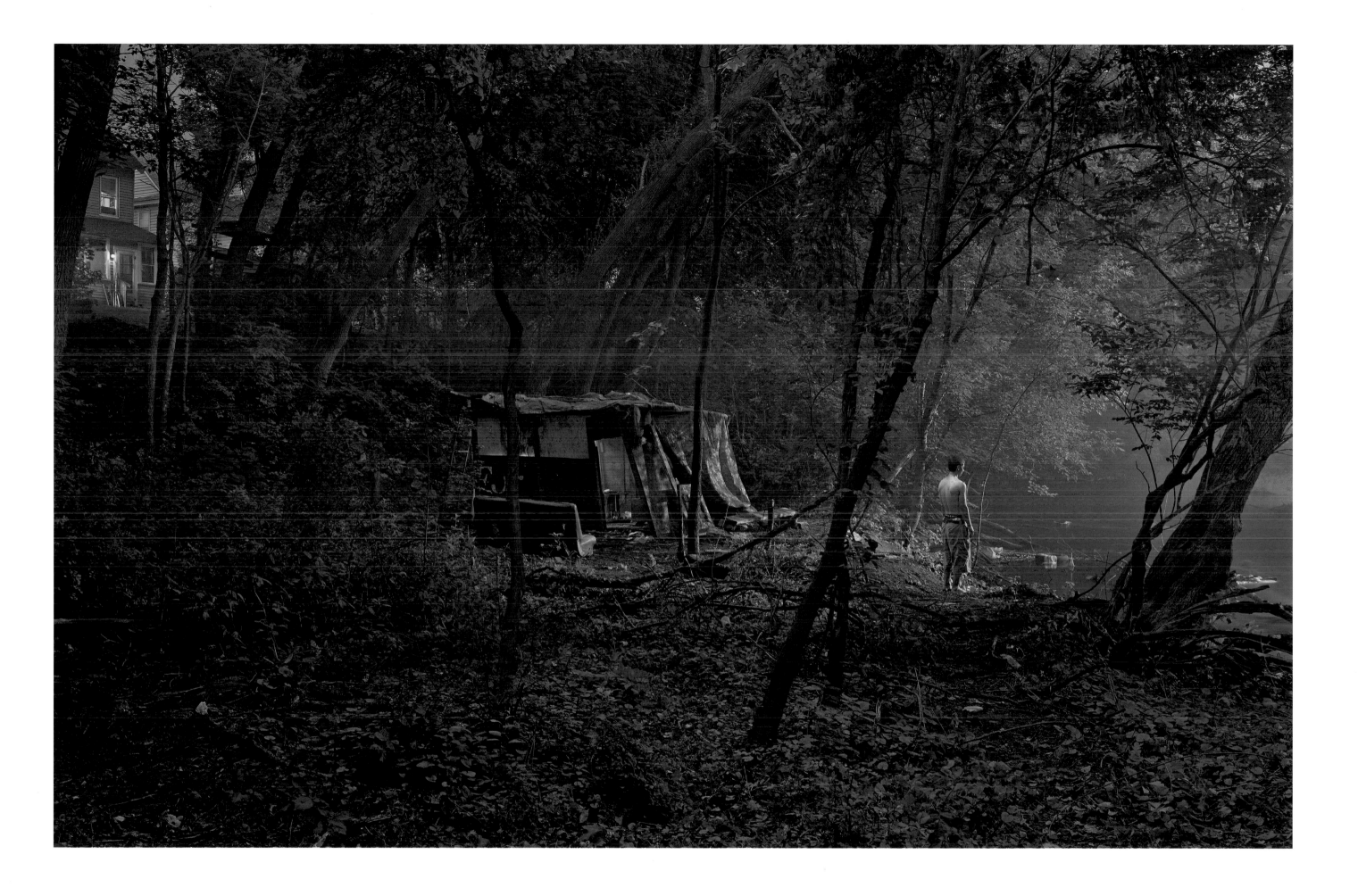

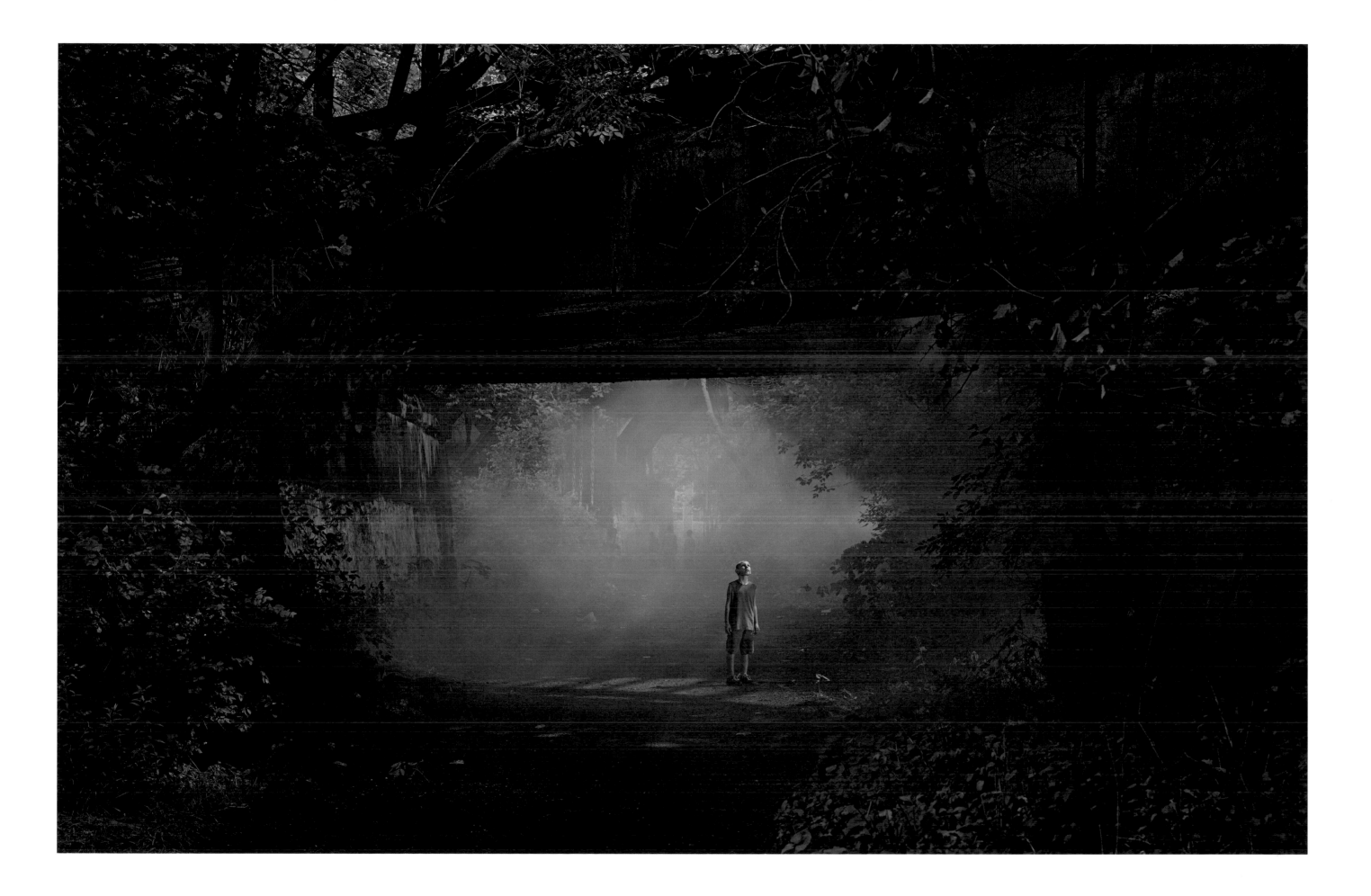

30.

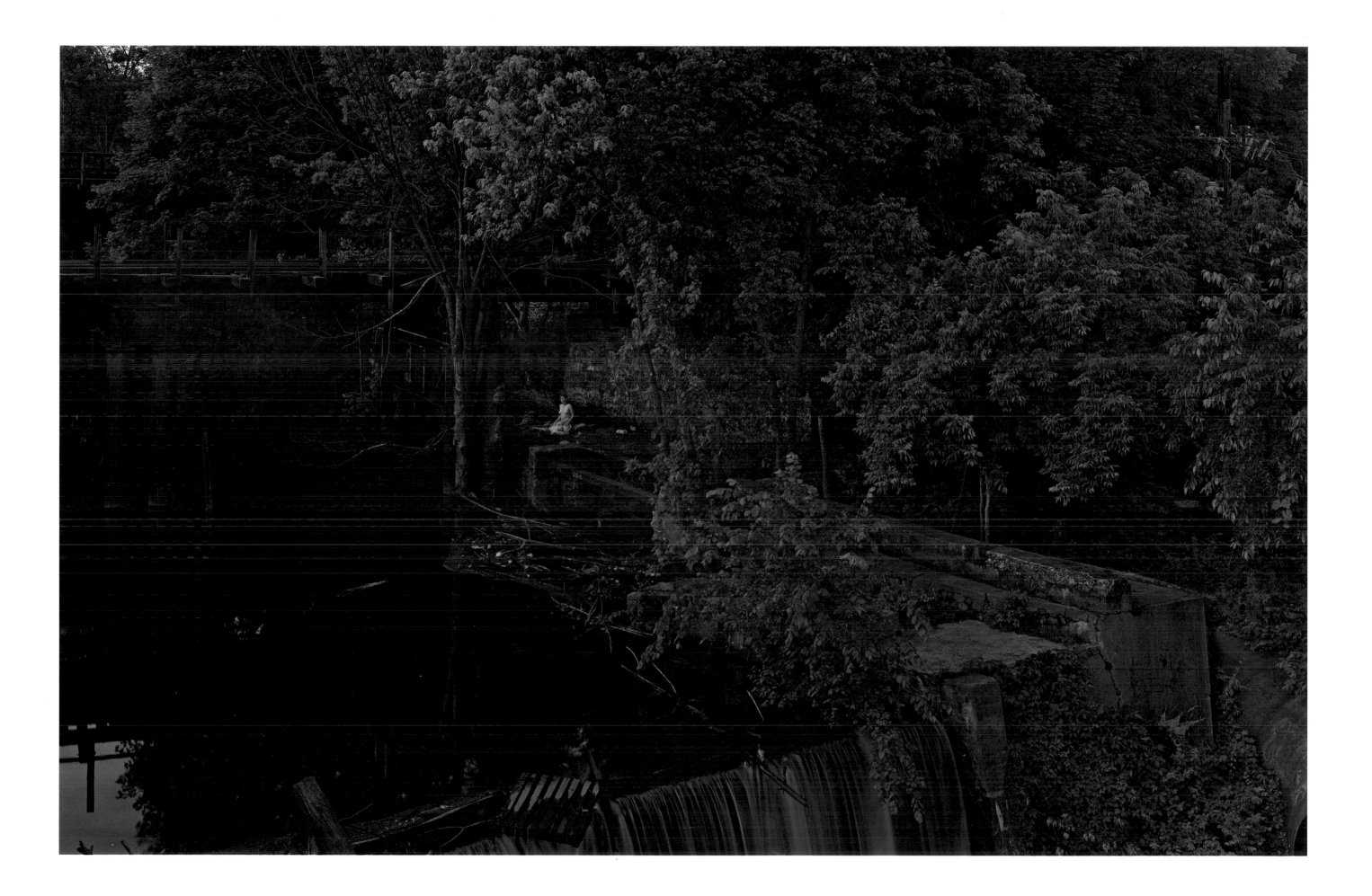

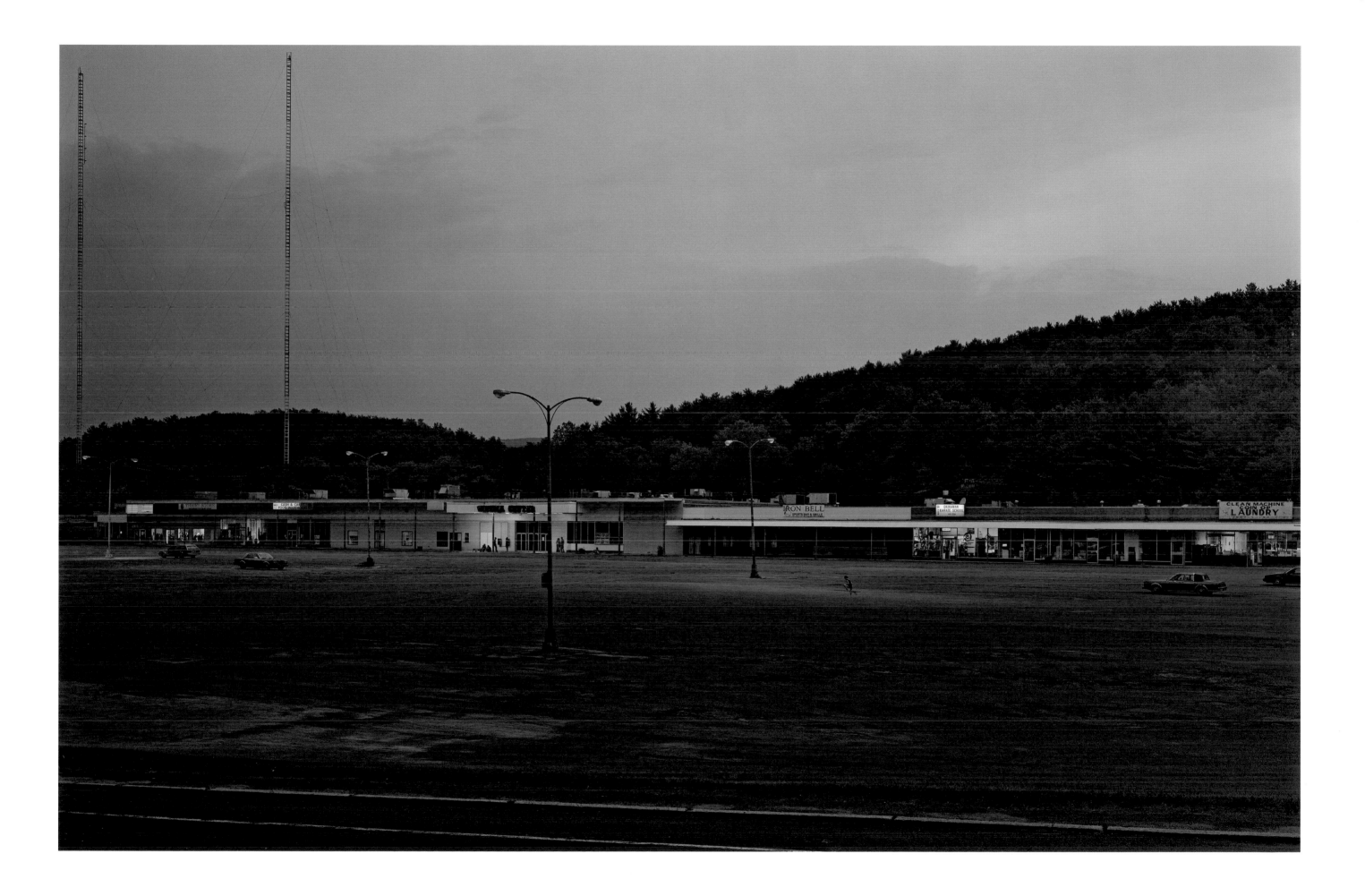

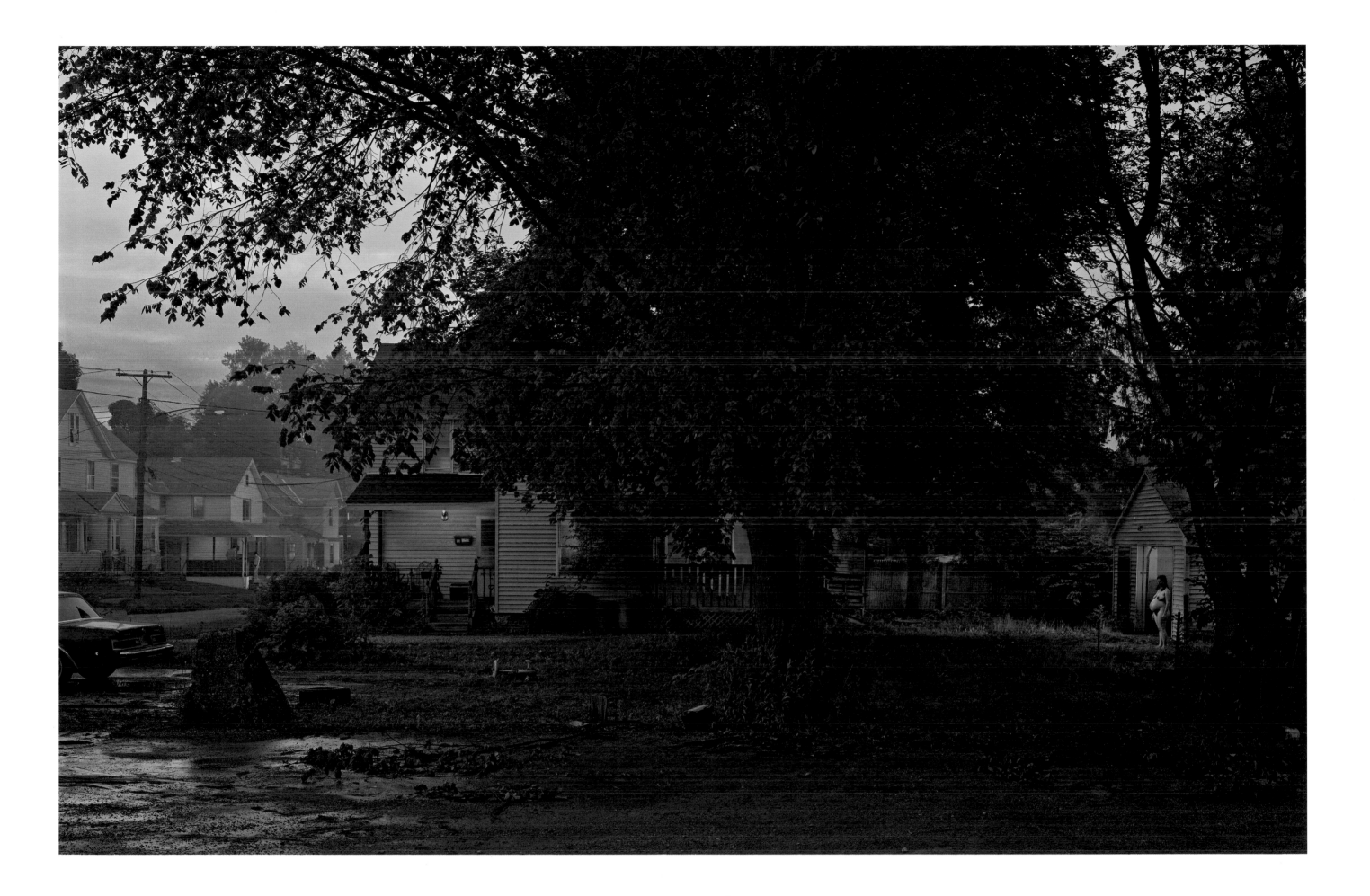

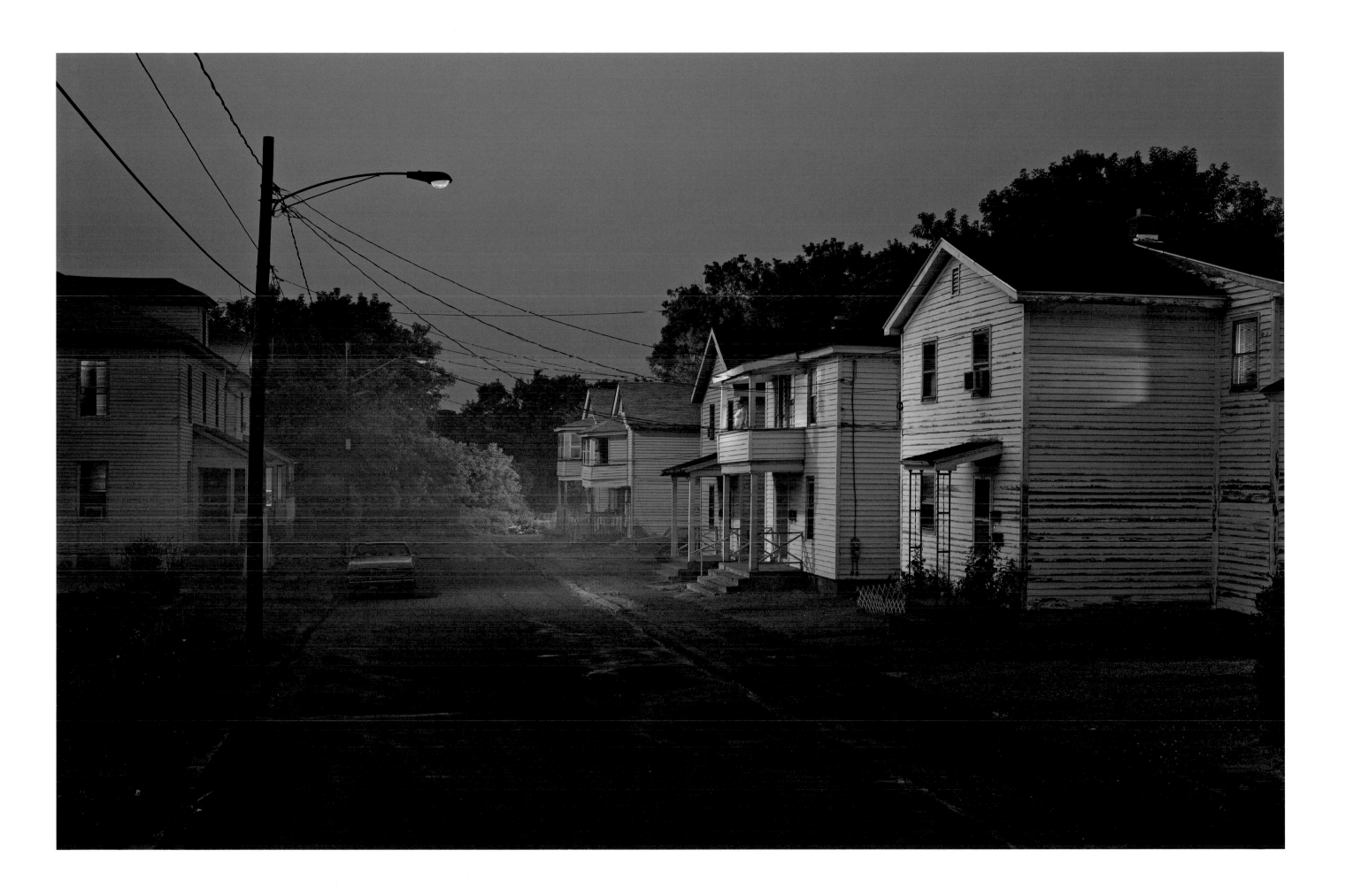

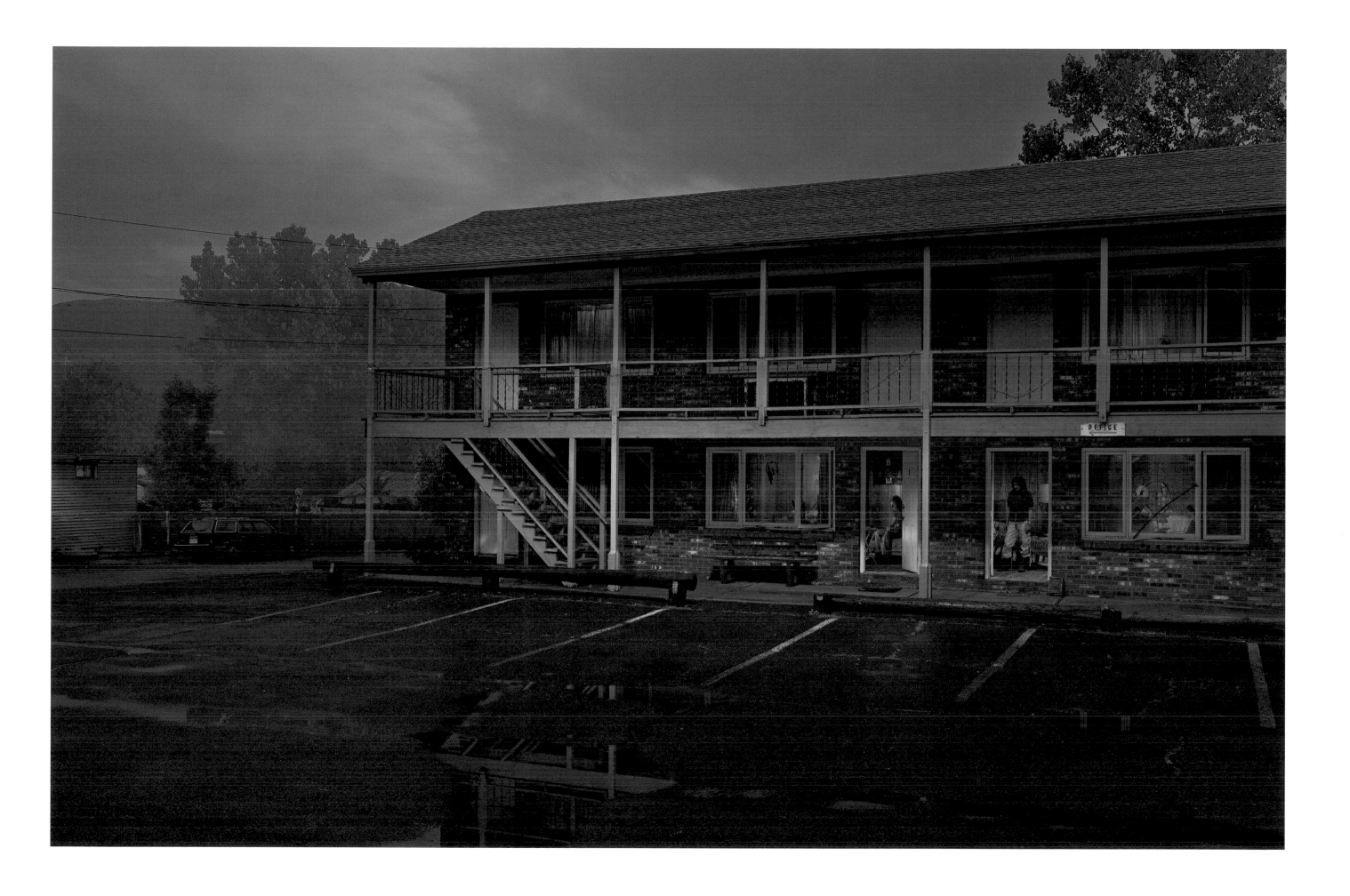

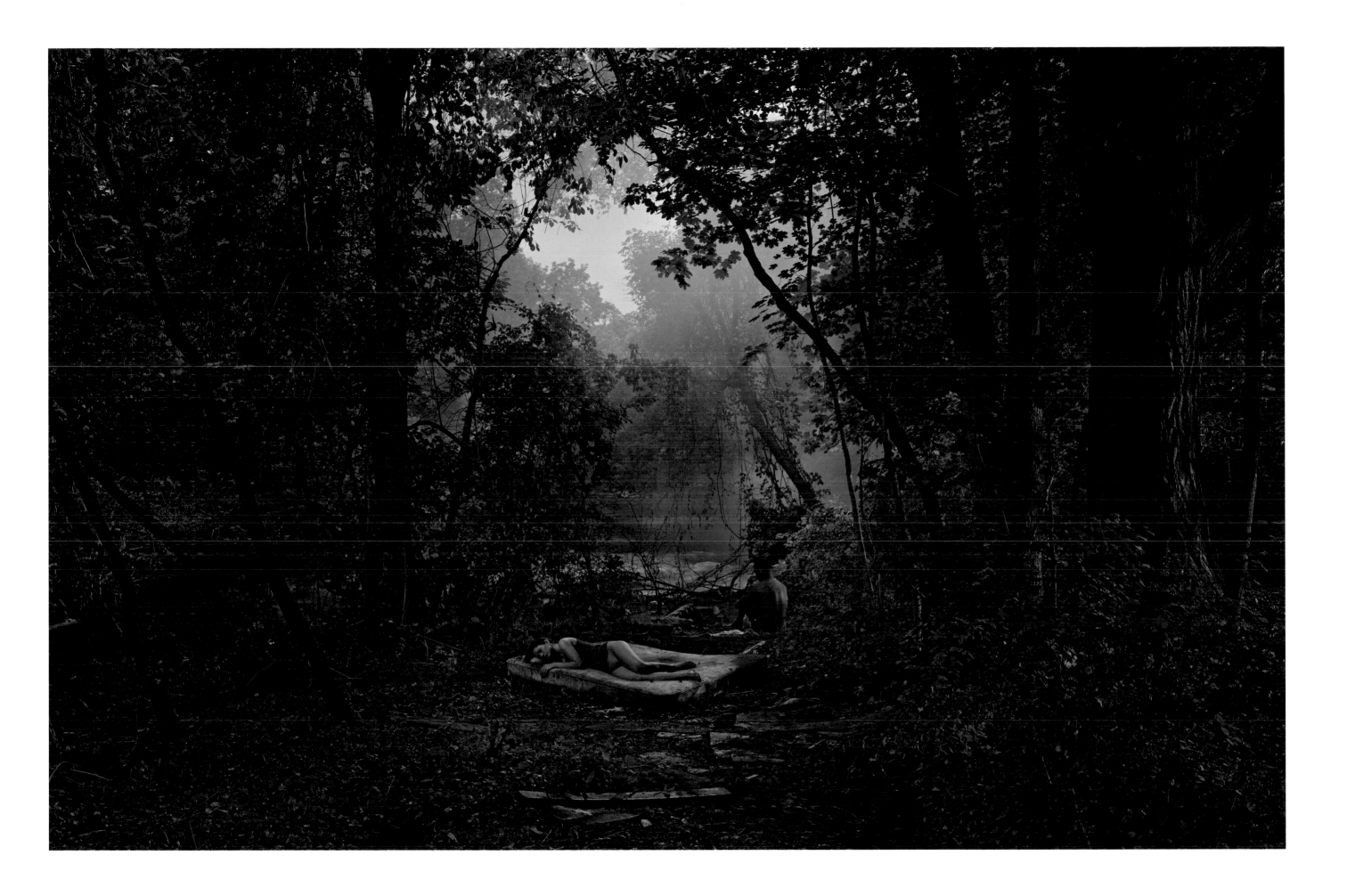

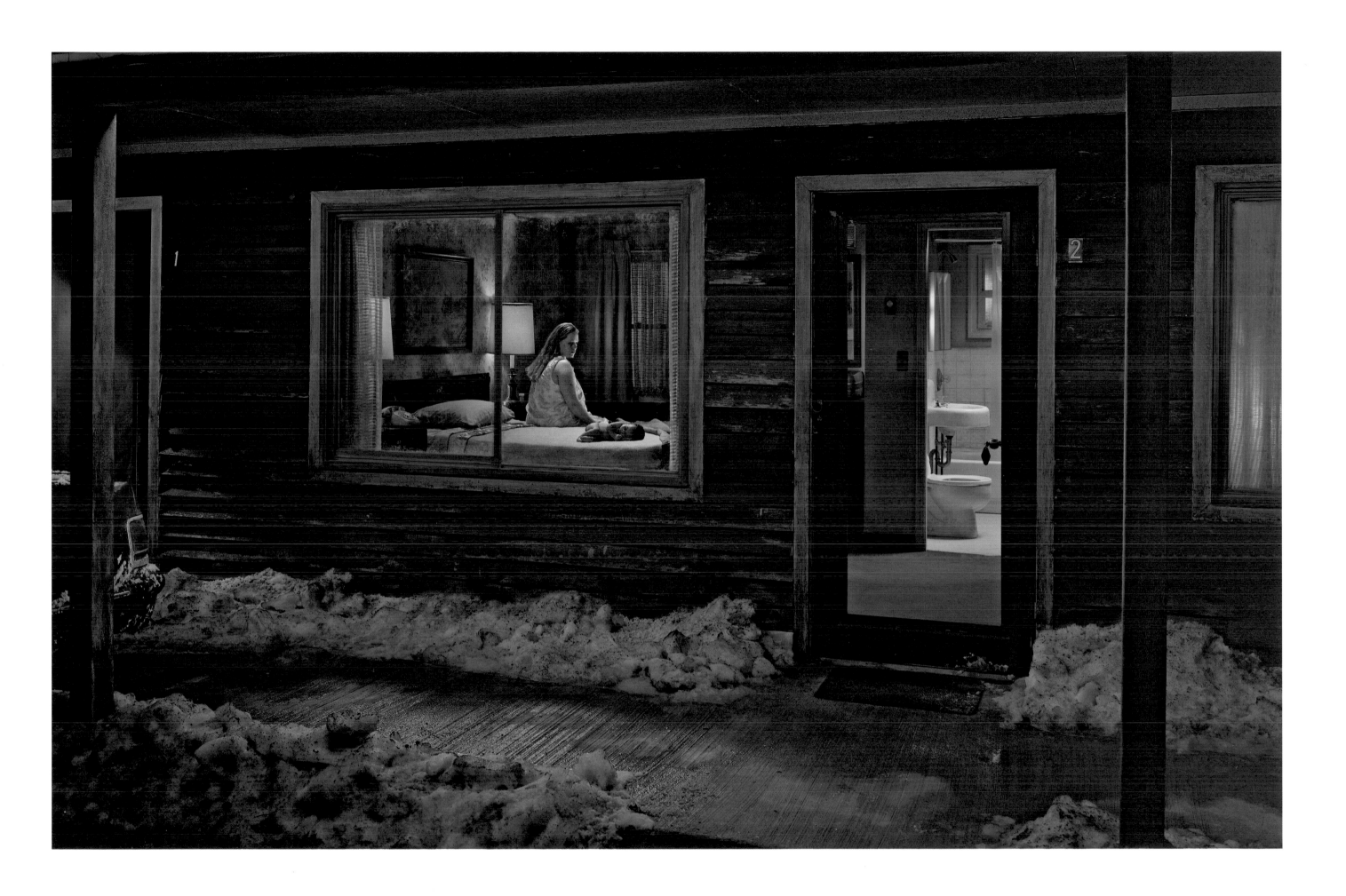

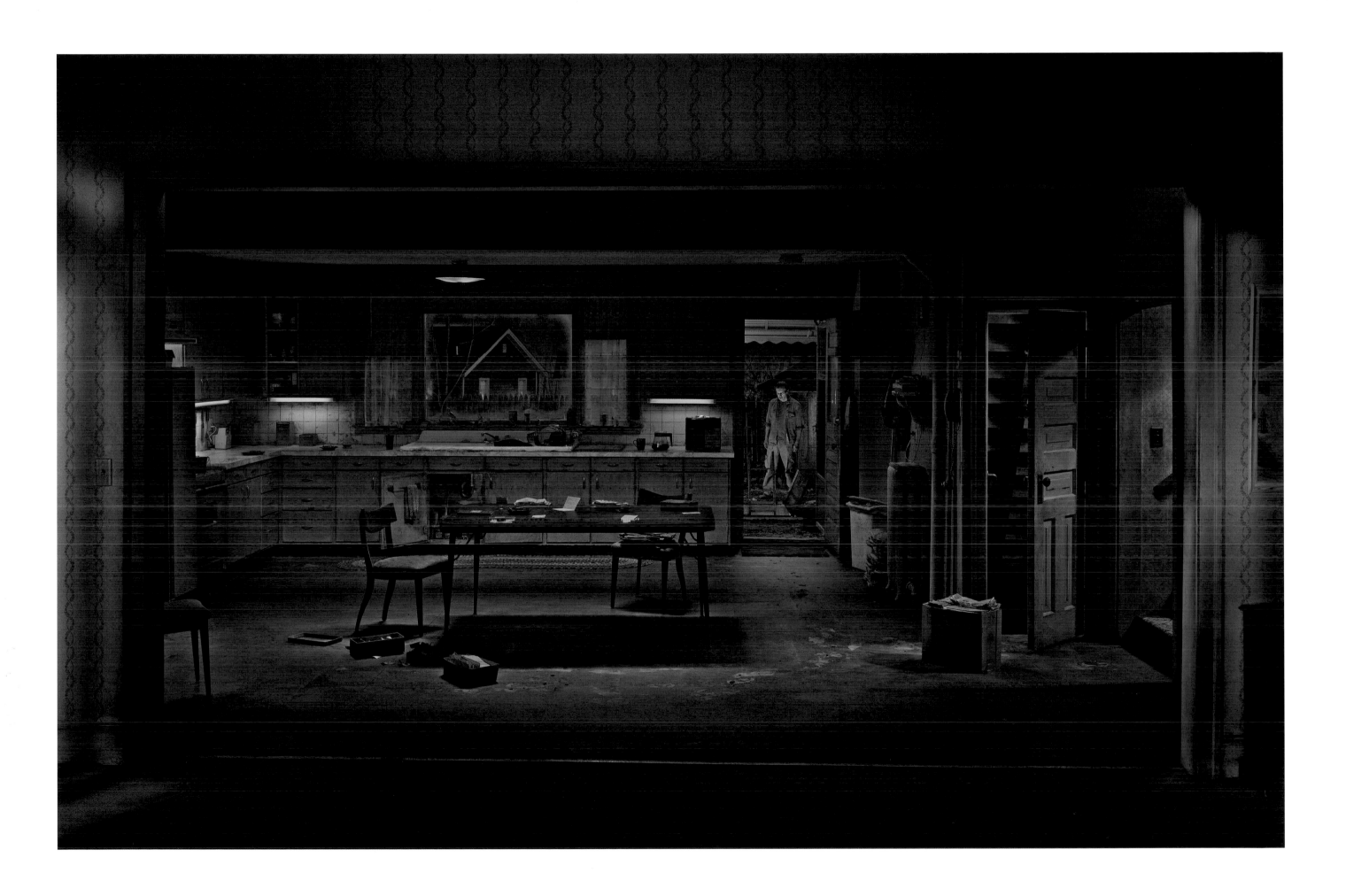

38.

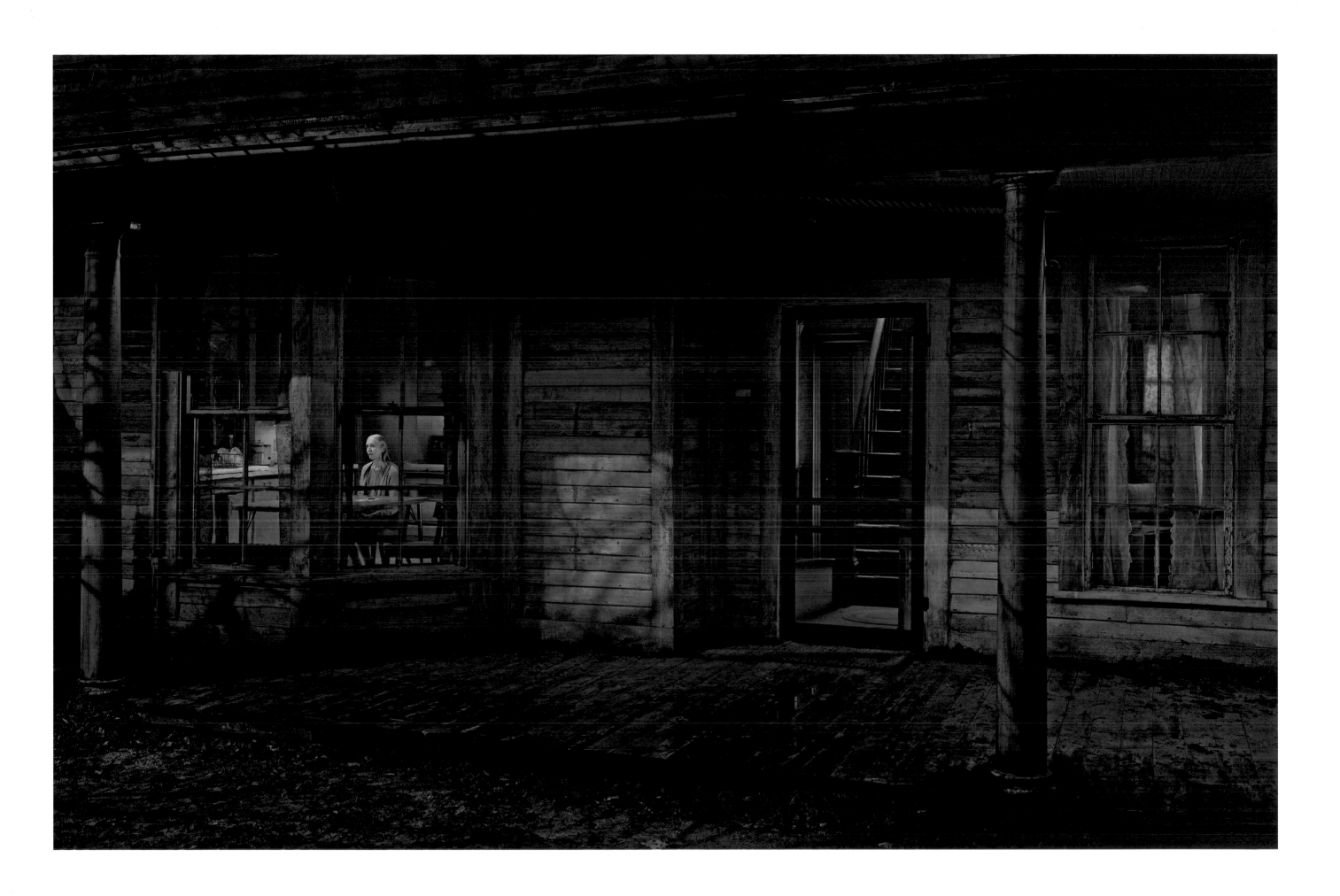

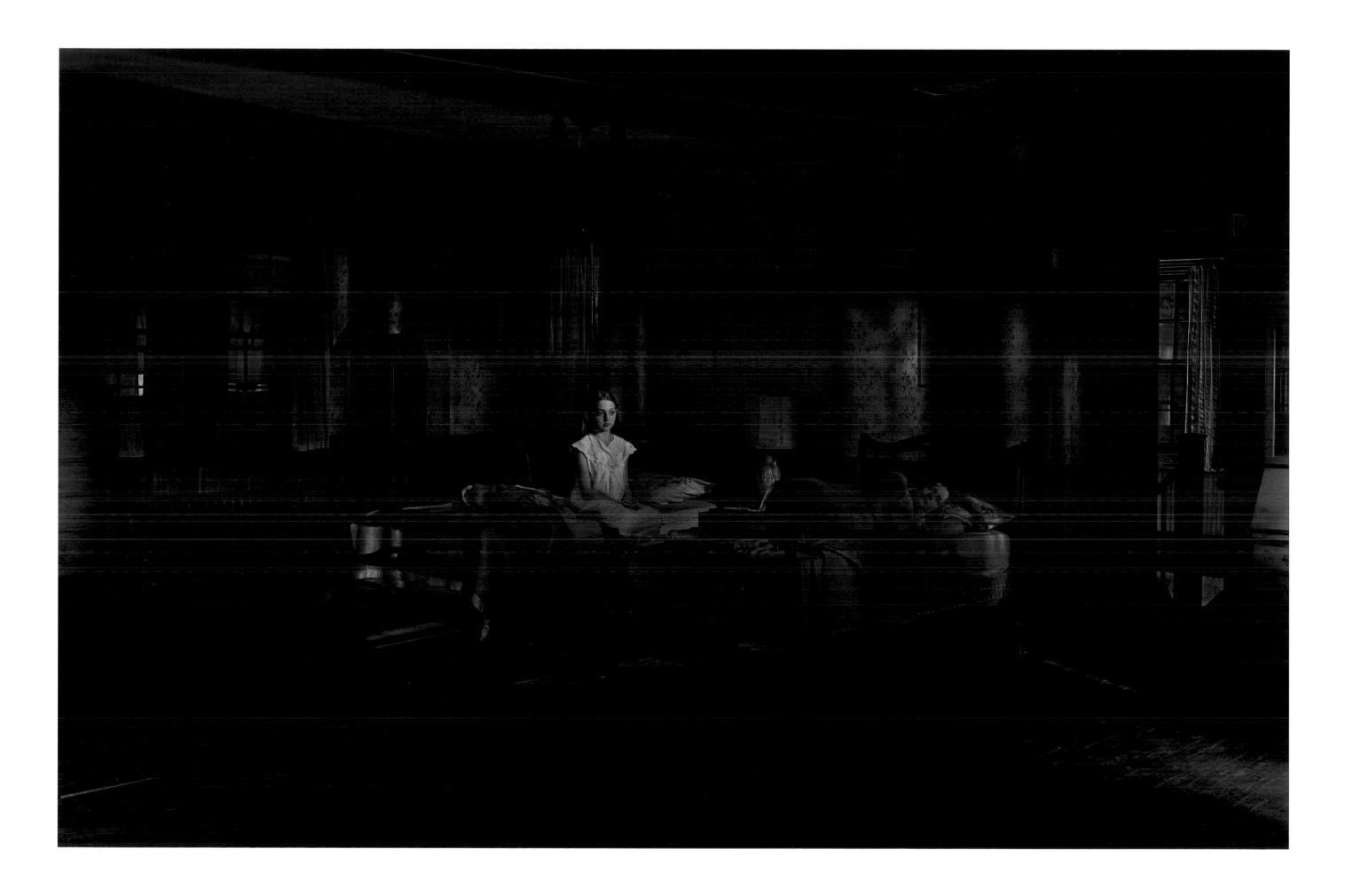

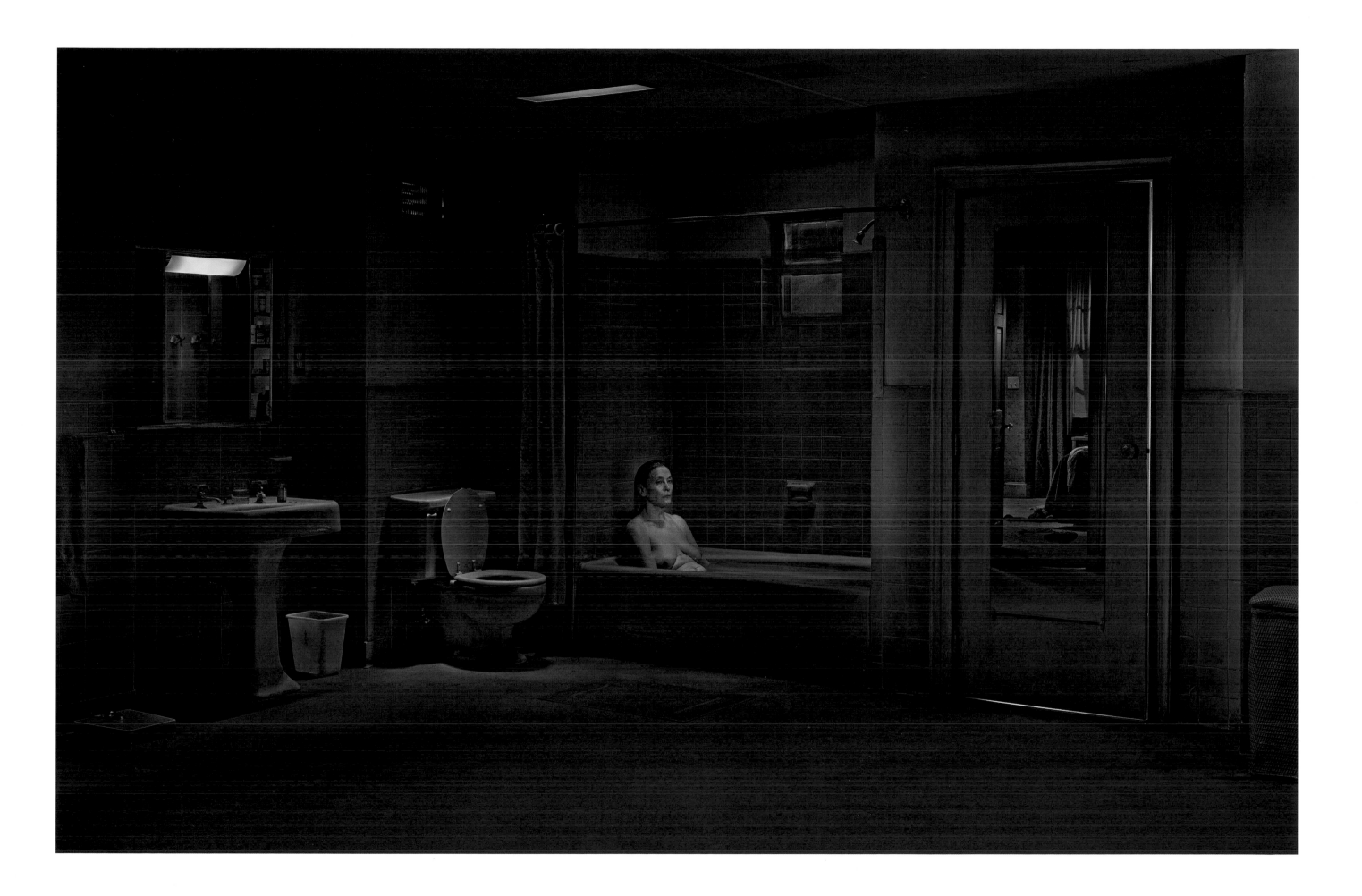

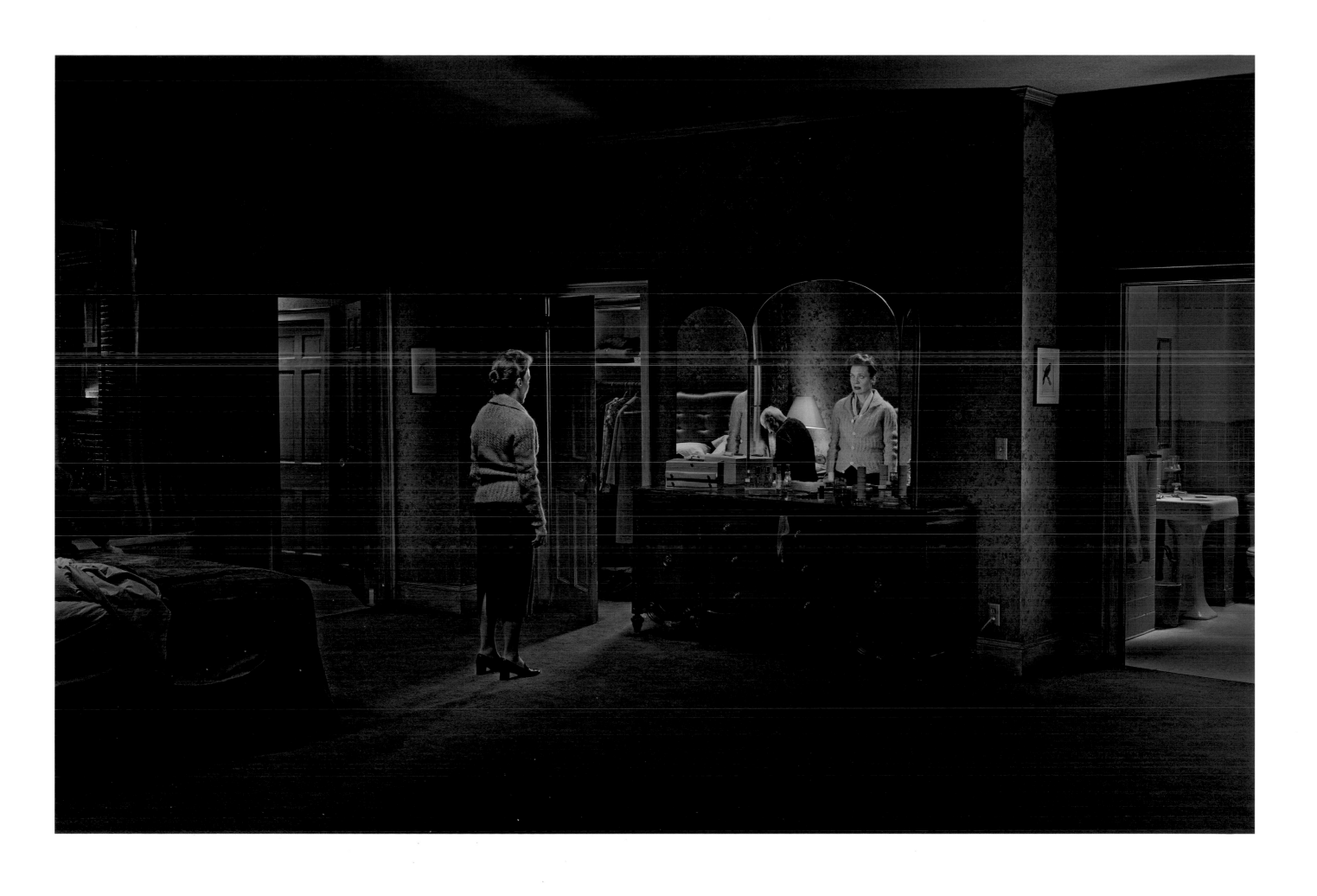

42.

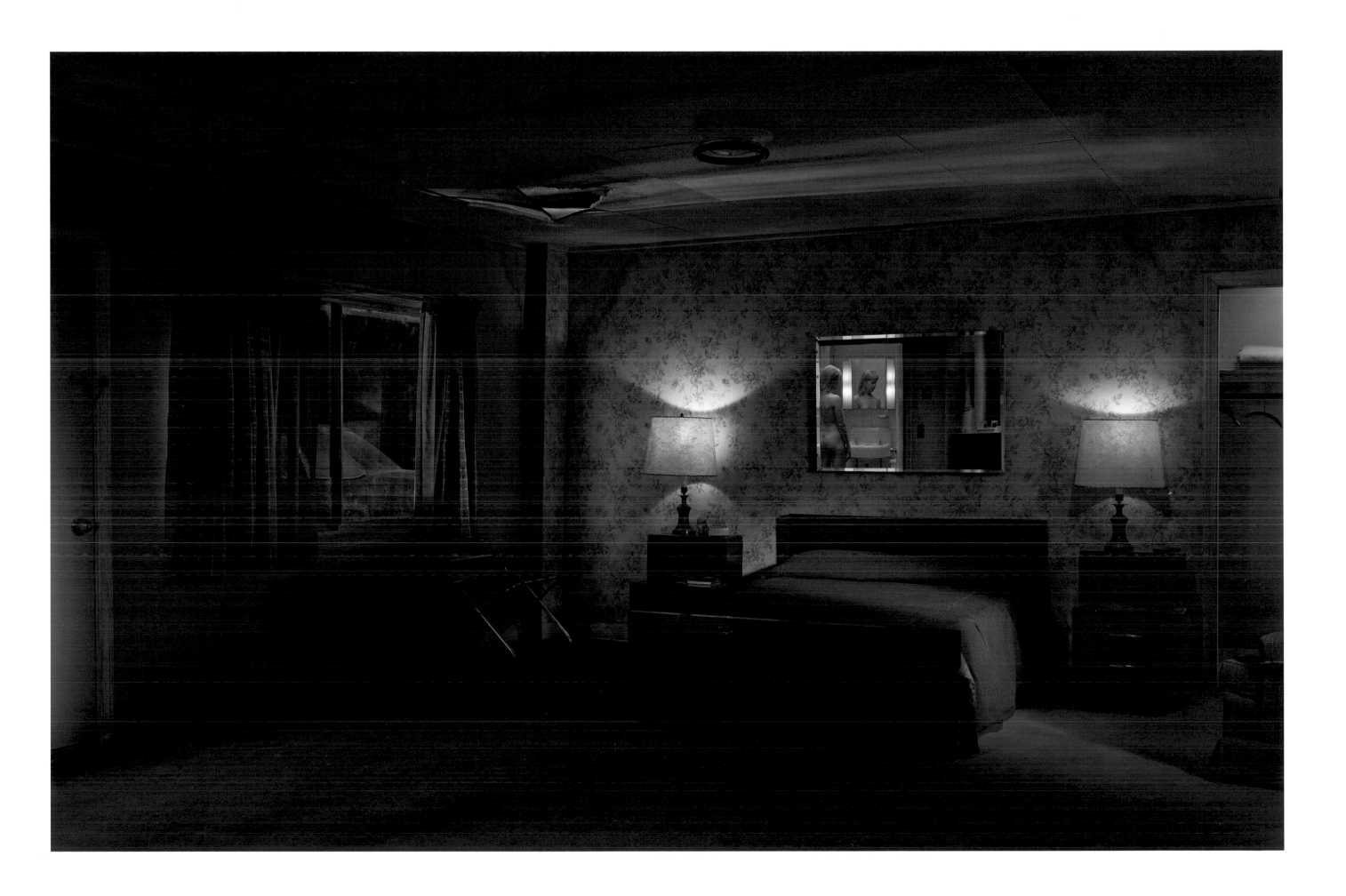

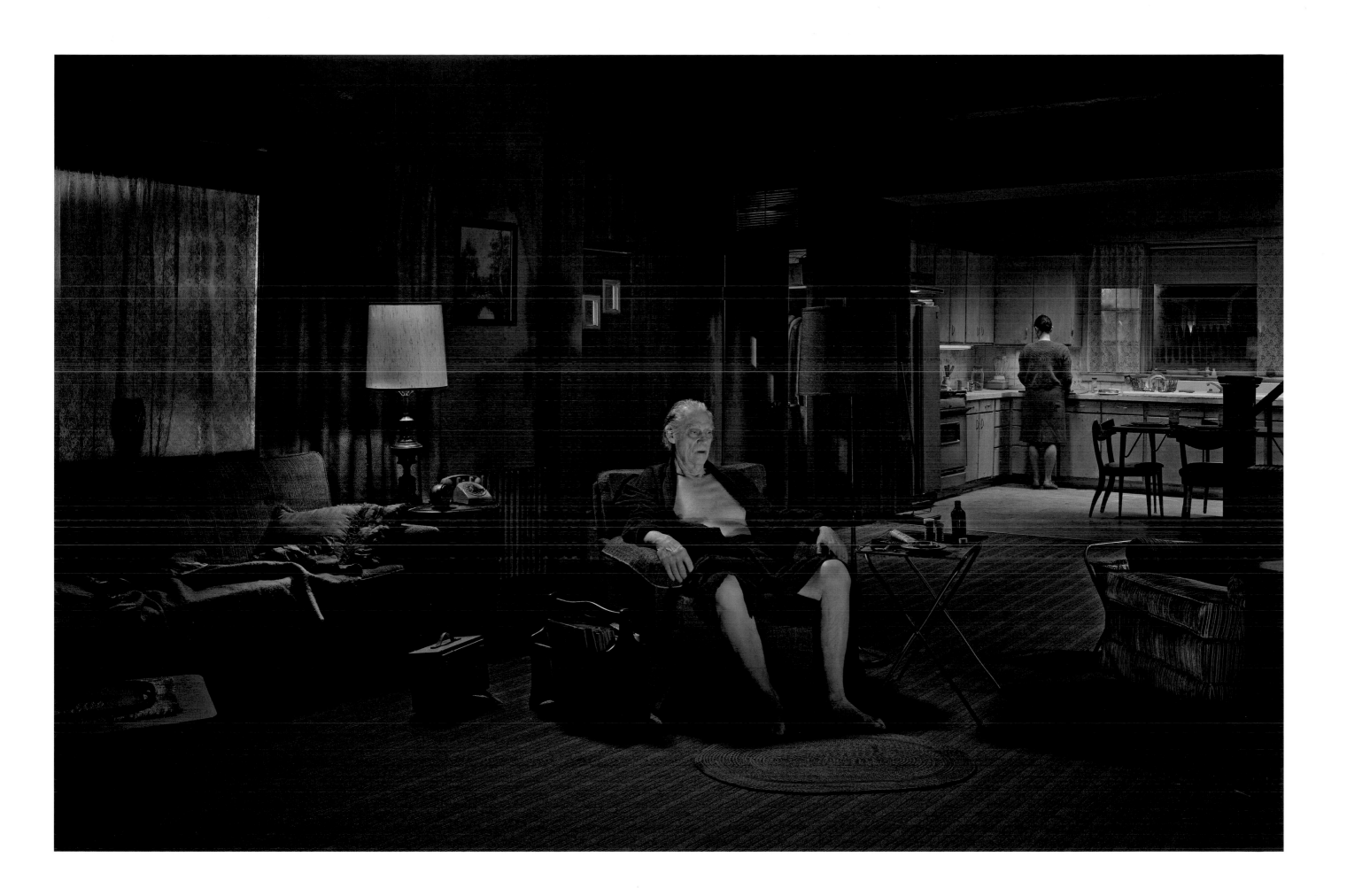

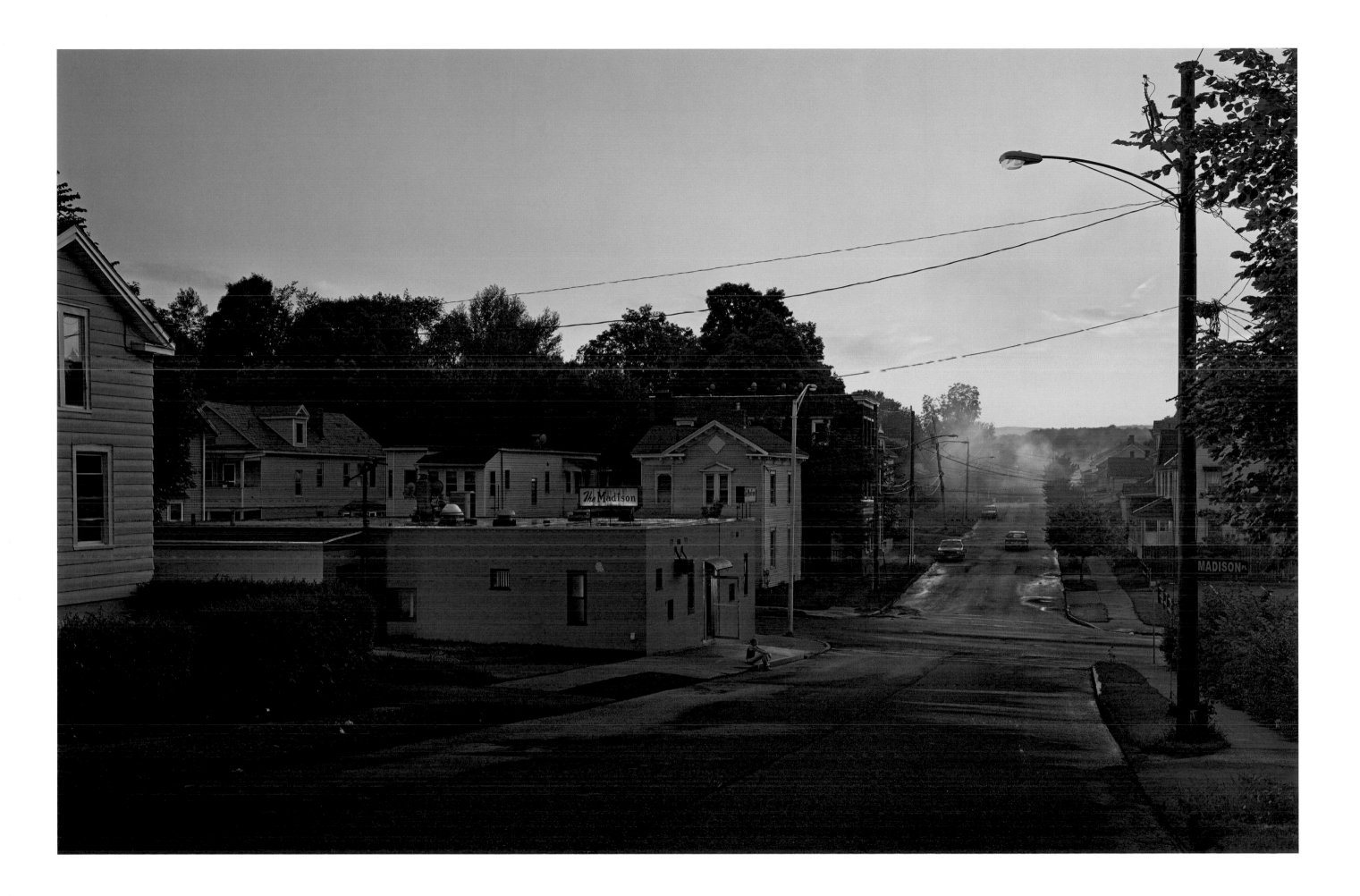

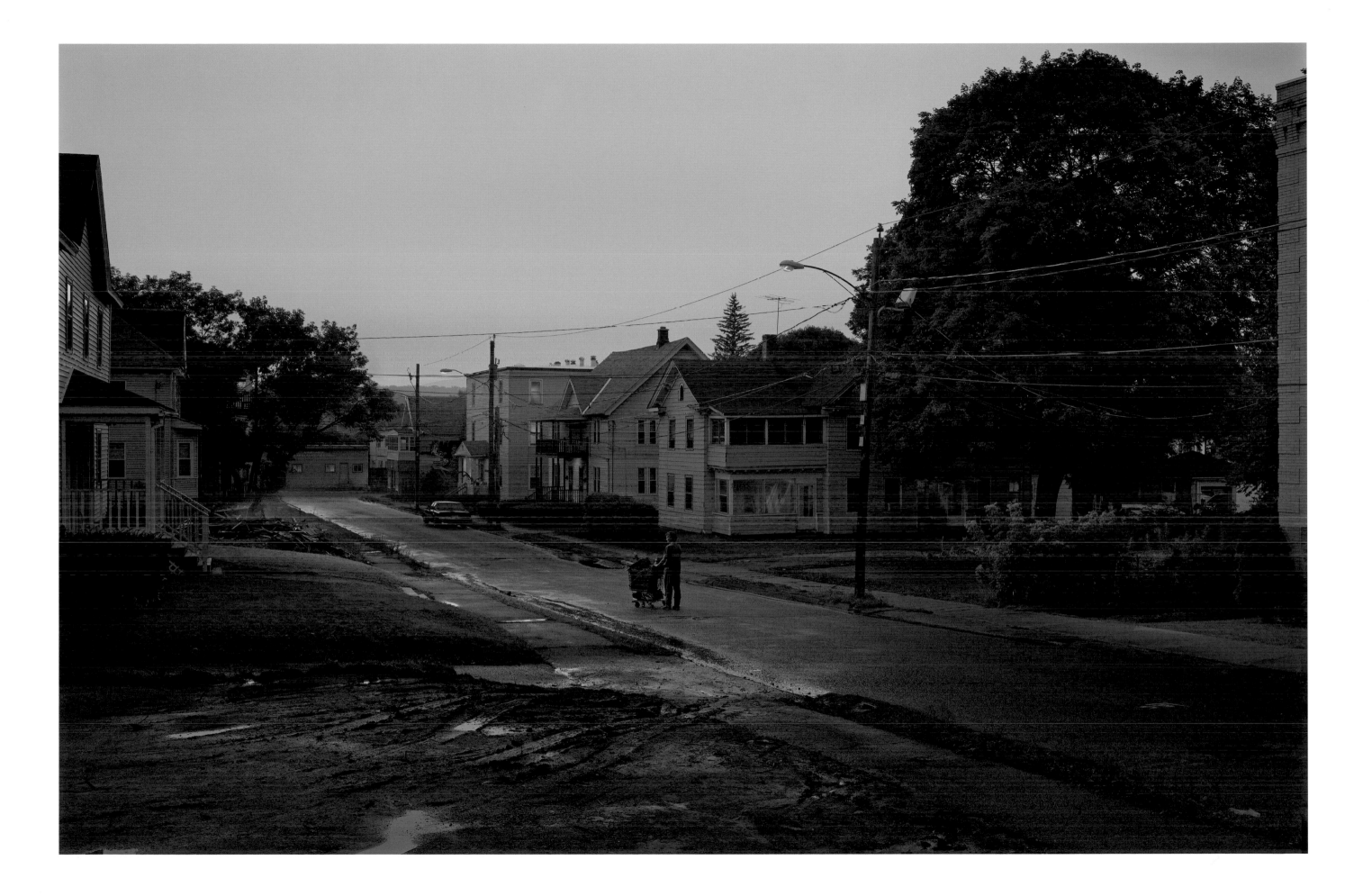

46.

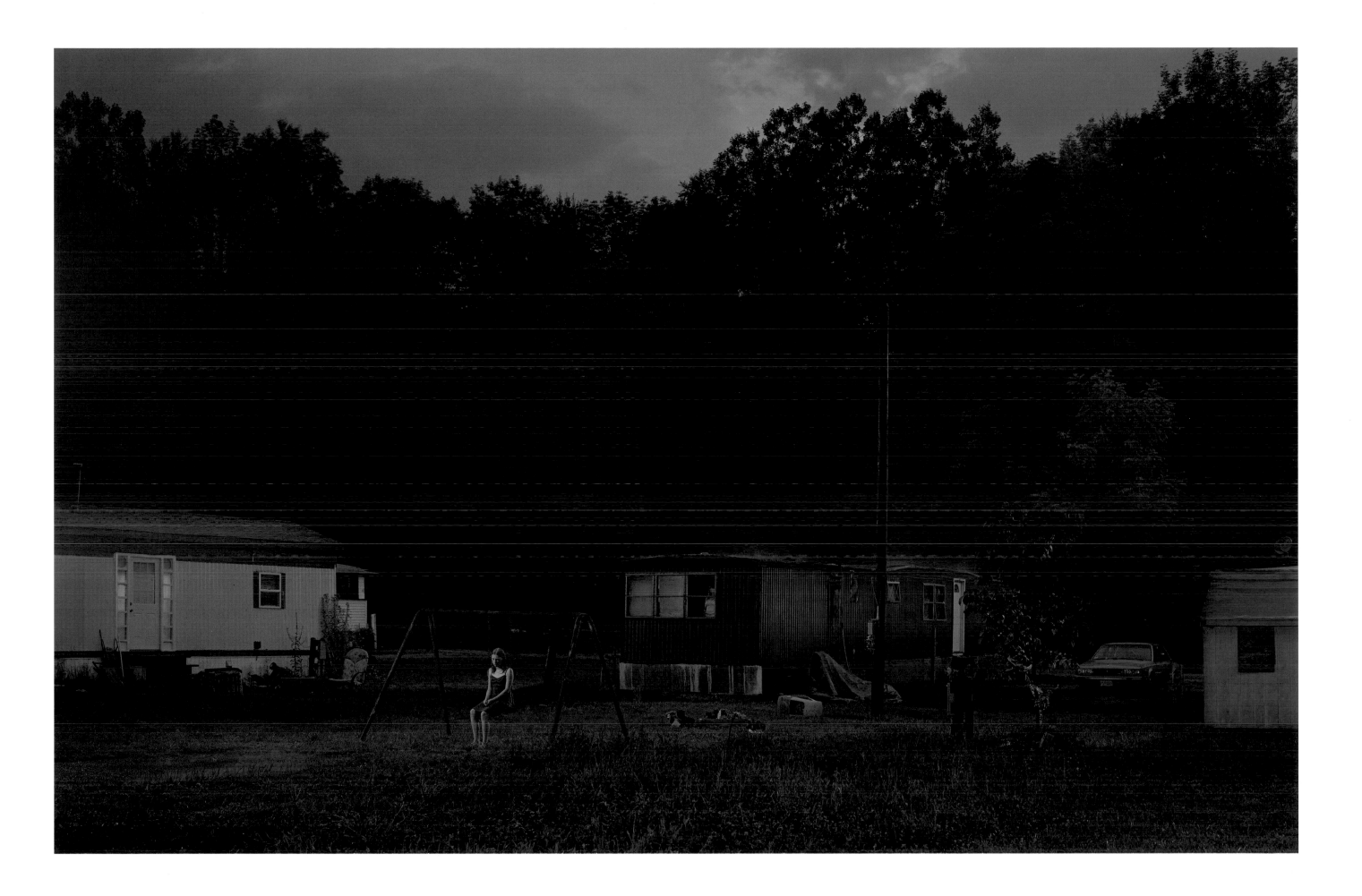

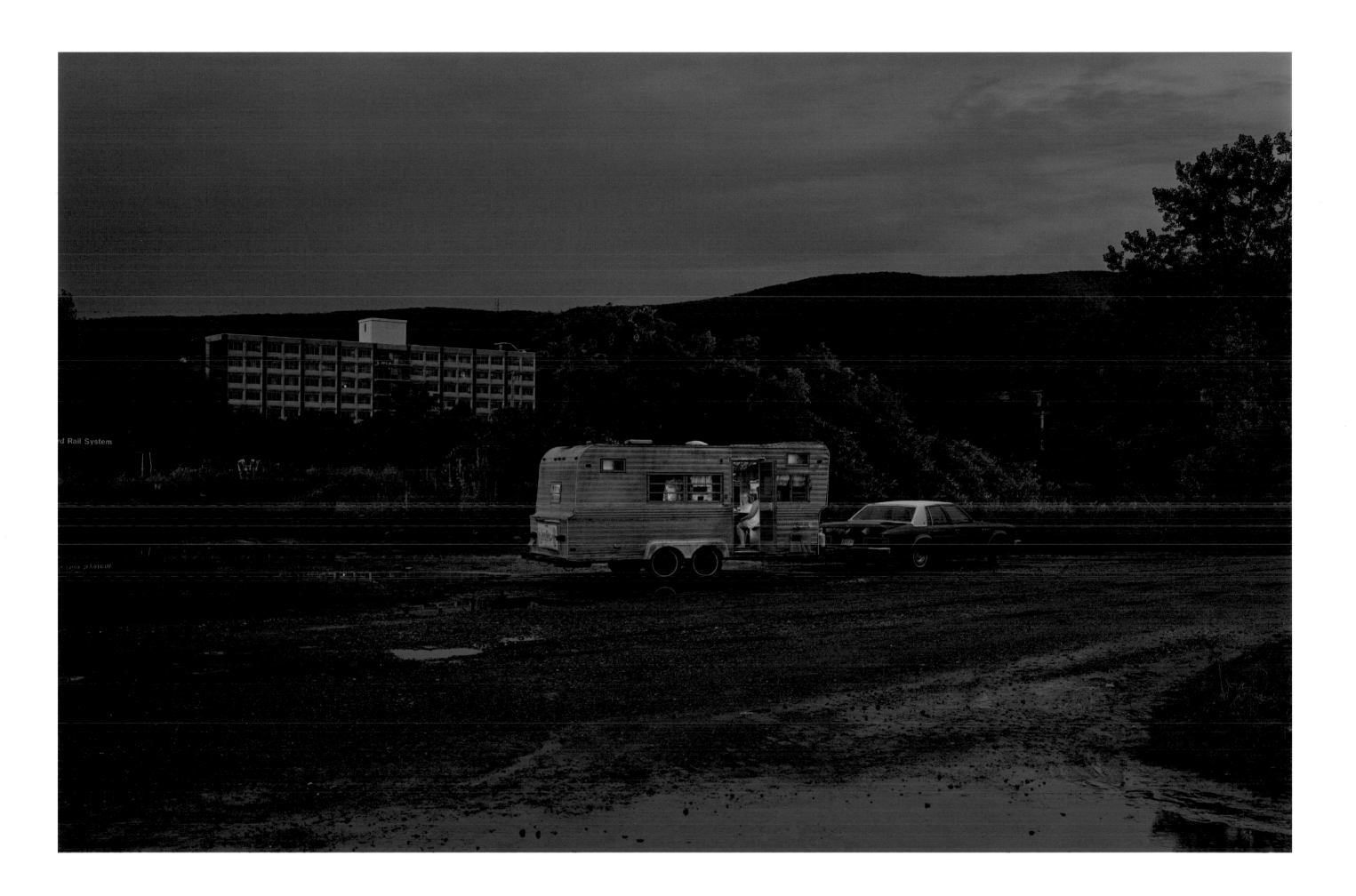

48.

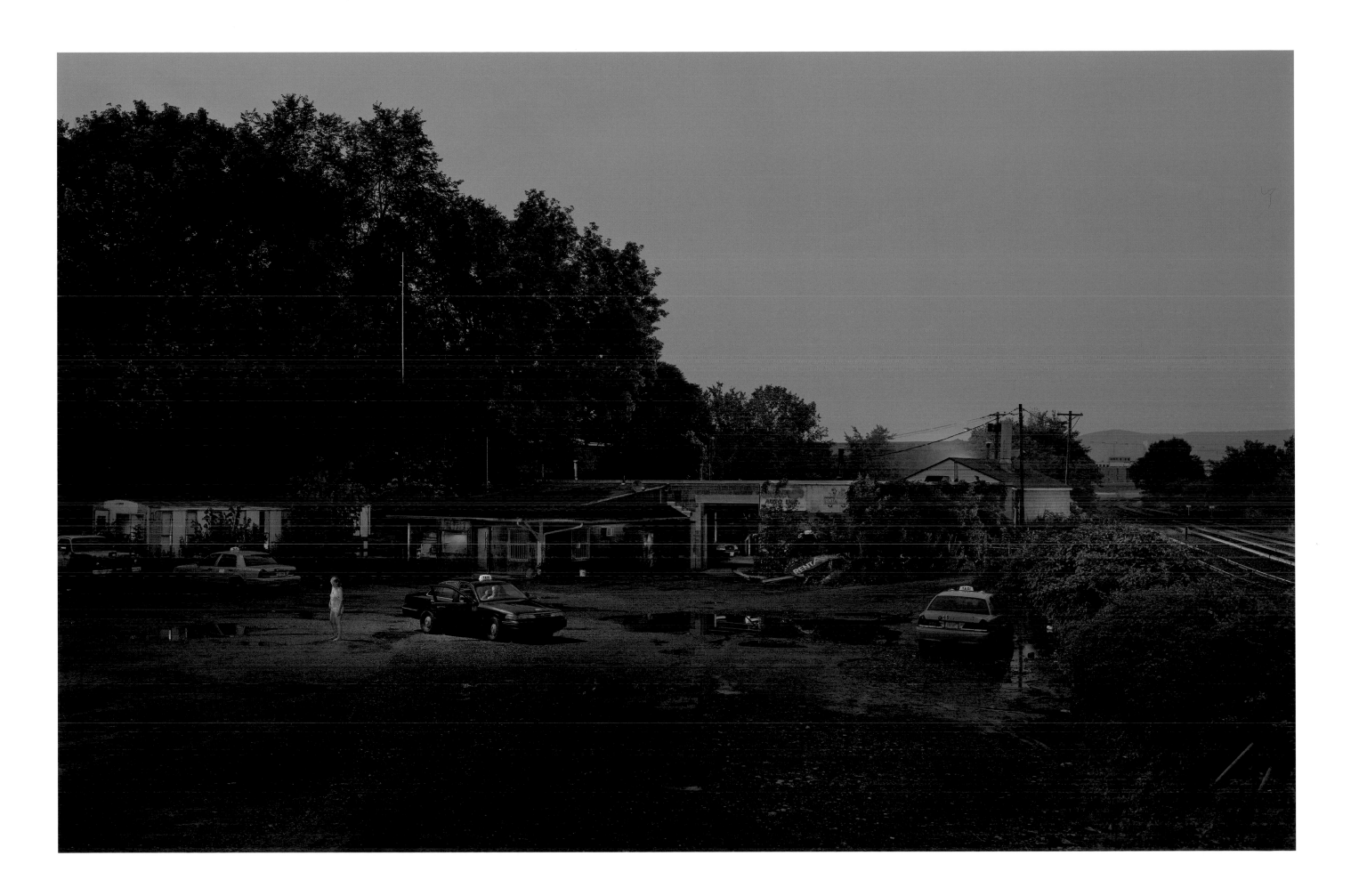

49.

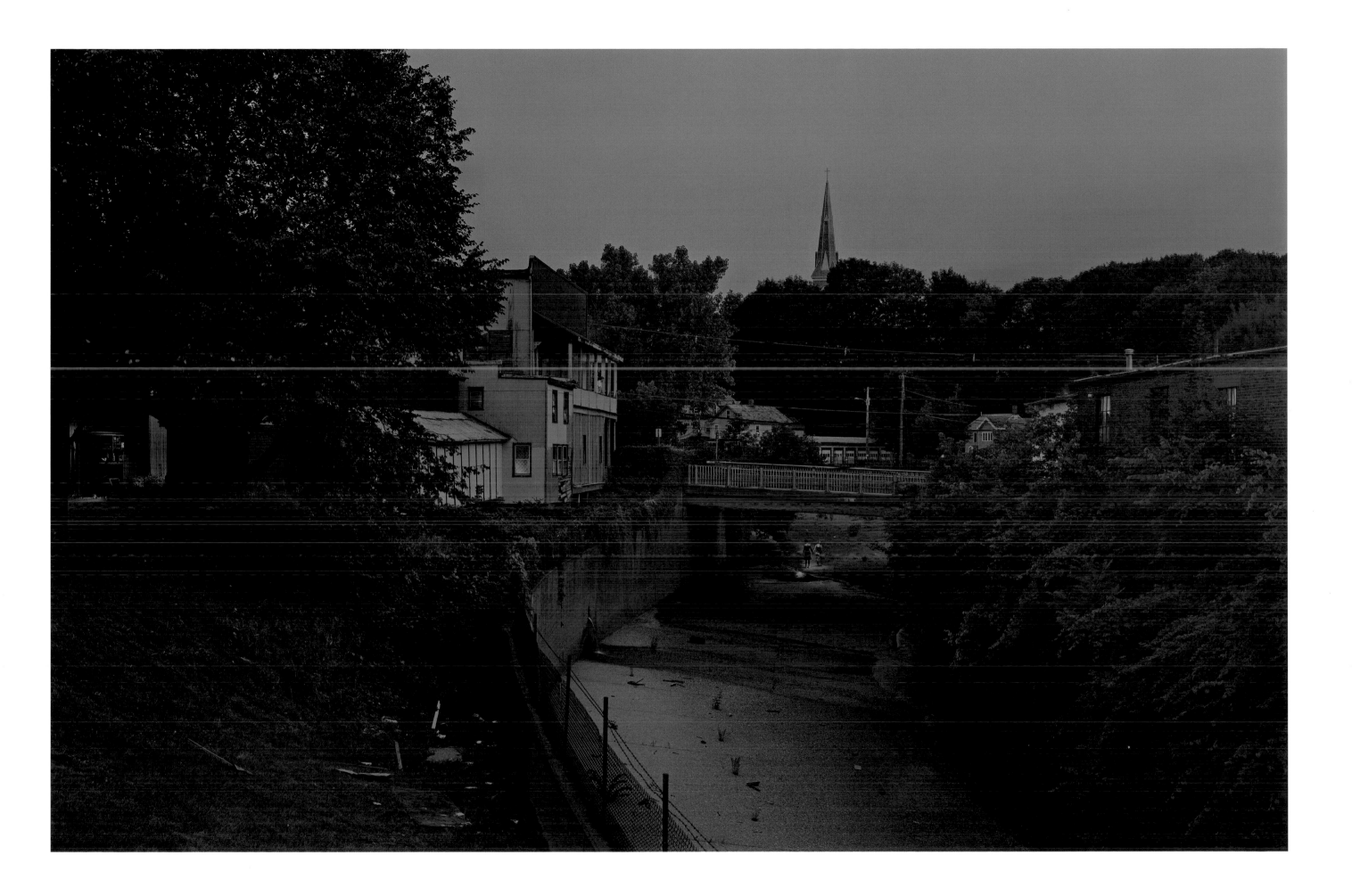

PRODUCTION MATERIAL

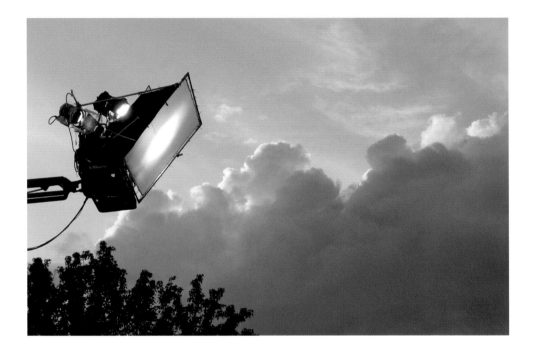

PRODUCTION STILL, COSTANZA THEODOLI-BRASCHI, SUMMER 2006

LOCATION

What follows is documentation from the "Beneath the Roses" location shoots, made between 2003 and 2007 in five productions. Summer 2003 production took place in Rutland, Vermont. Summer 2004, 2006, and 2007 productions and winter 2006 production were in Adams, North Adams, and Pittsfield, Massachusetts. The following material consists of production stills, lighting plots, location documents, and Polaroids from these shoots.

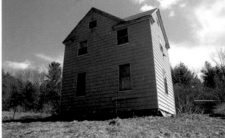
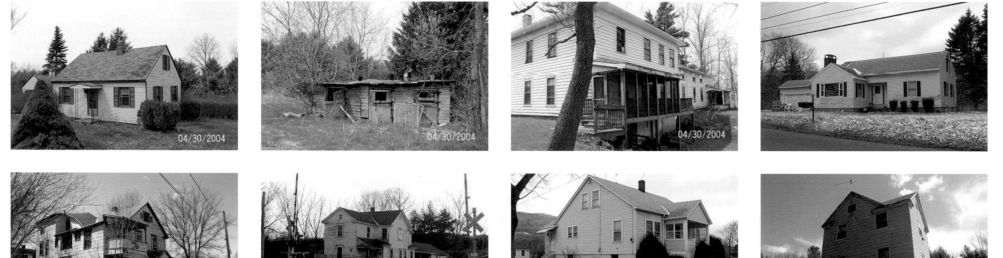

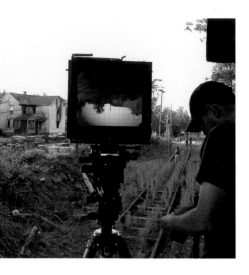

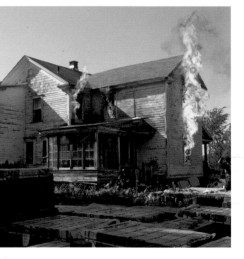

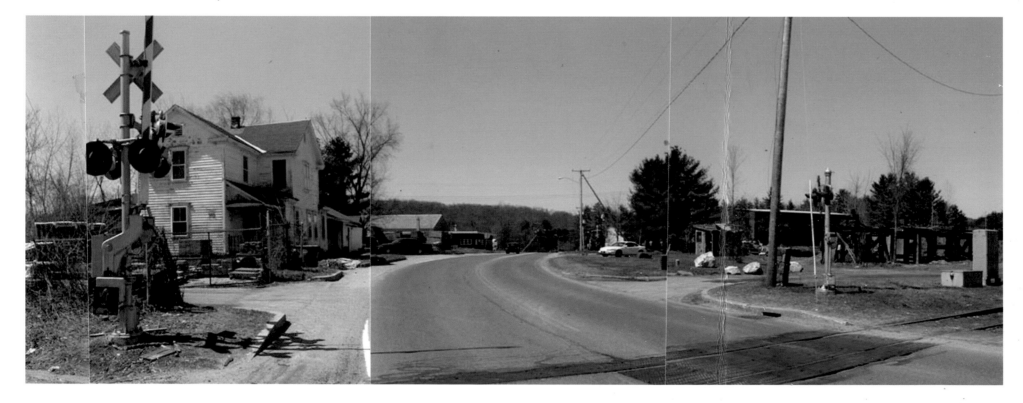

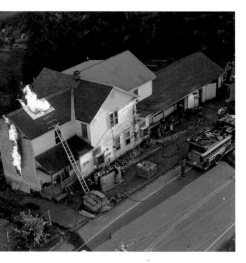

CLOCKWISE FROM TOP LEFT: HOUSE BURN OPTIONS, LAURA BERNING, SUMMER 2004; PRODUCTION STILL, LAURA BERNING, SUMMER 2004; PRODUCTION STILL, DANIEL KARP, SUMMER 2004; PRODUCTION STILL, LAURA BERNING, SUMMER 2004; LOCATION SCOUT PHOTOGRAPH, LAURA BERNING, SUMMER 2004

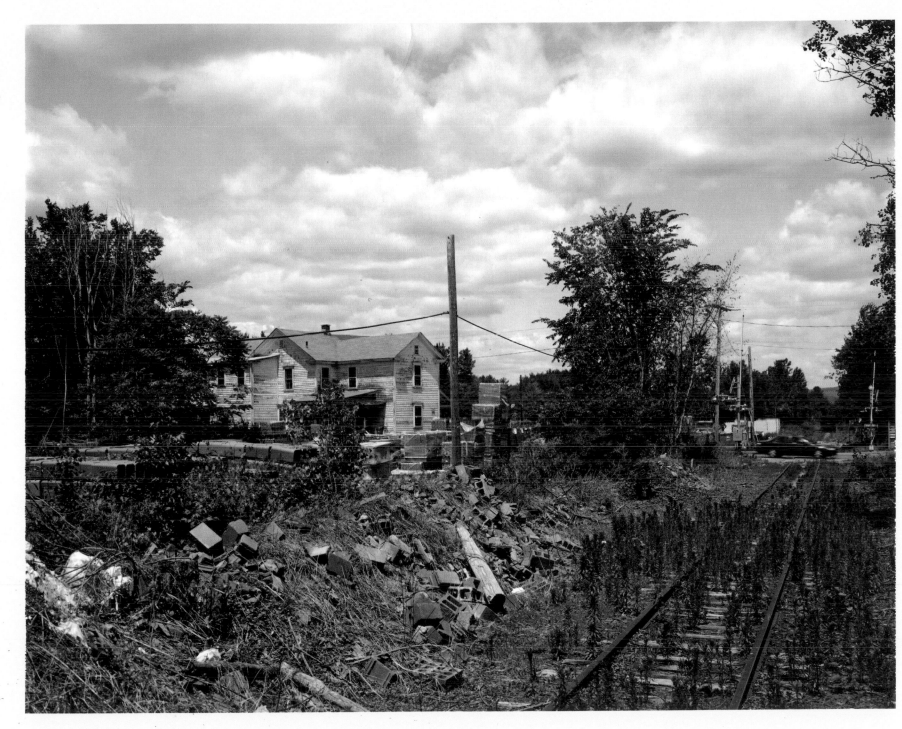

8 x 10" BLACK & WHITE POLAROID, DANIEL KARP, SUMMER 2004

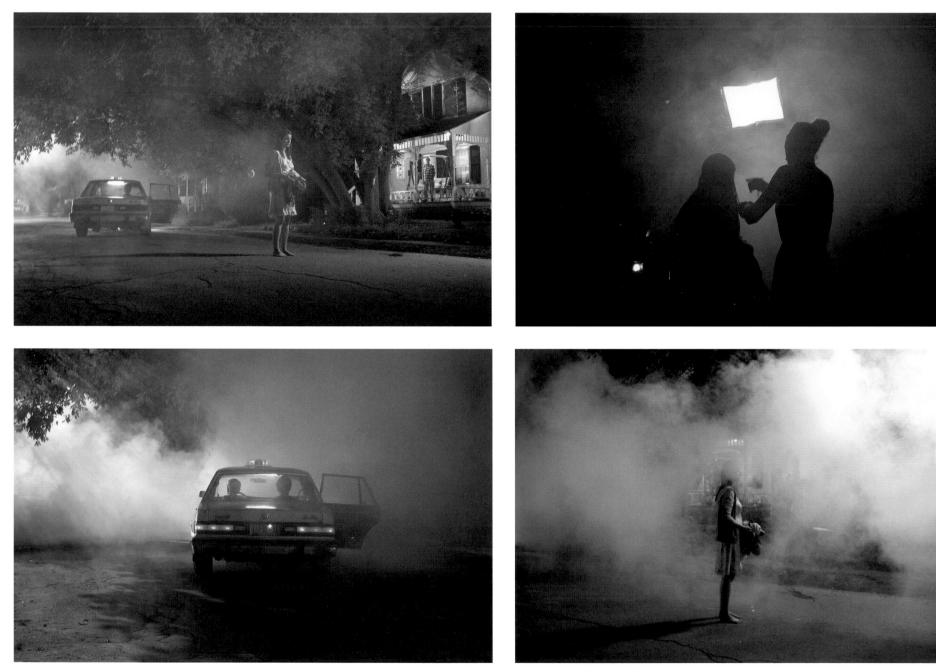

PRODUCTION STILLS, KEVIN RAPF, SUMMER 2003

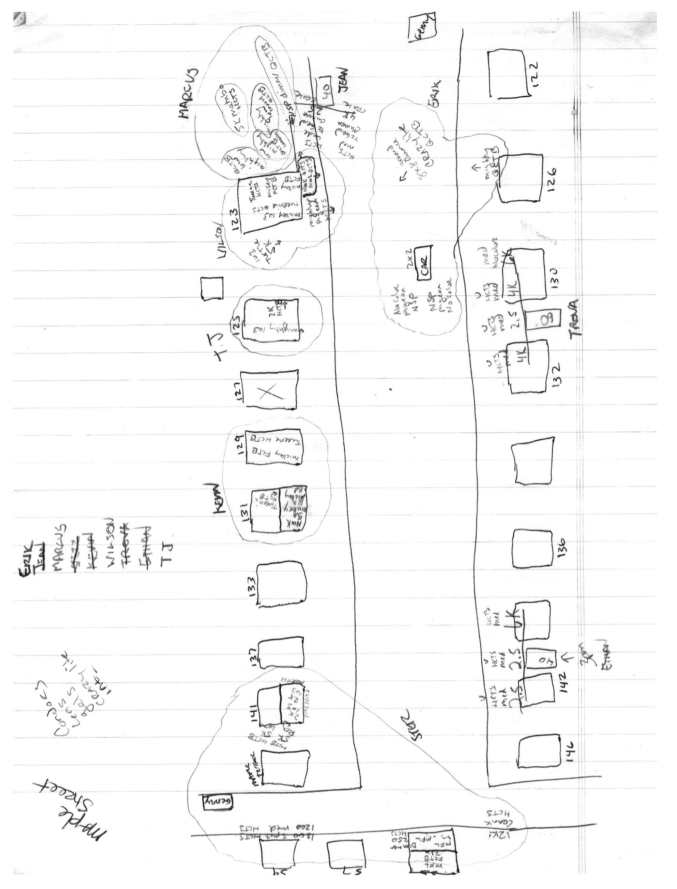

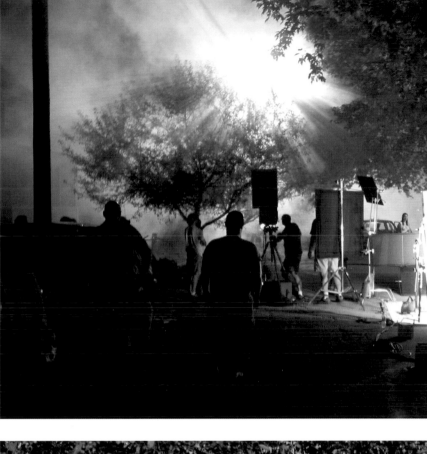

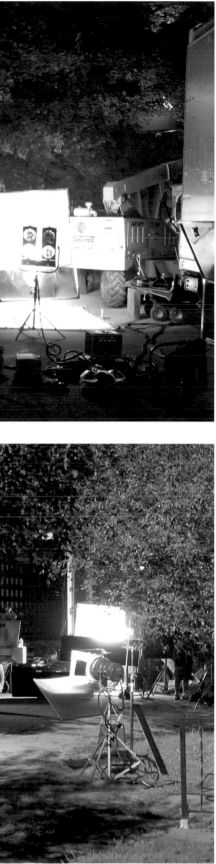

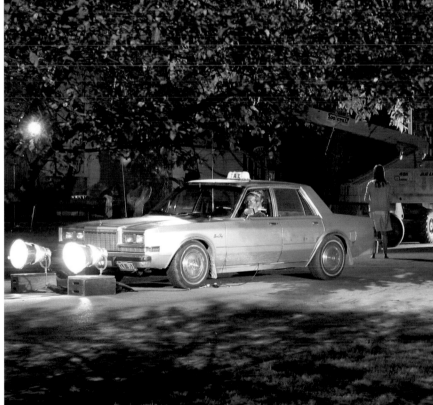

CLOCKWISE FROM LEFT: LIGHTING PLOT, DEIDRE LALLY, SUMMER 2003; PRODUCTION STILLS, KEVIN RAPF, SUMMER 2003

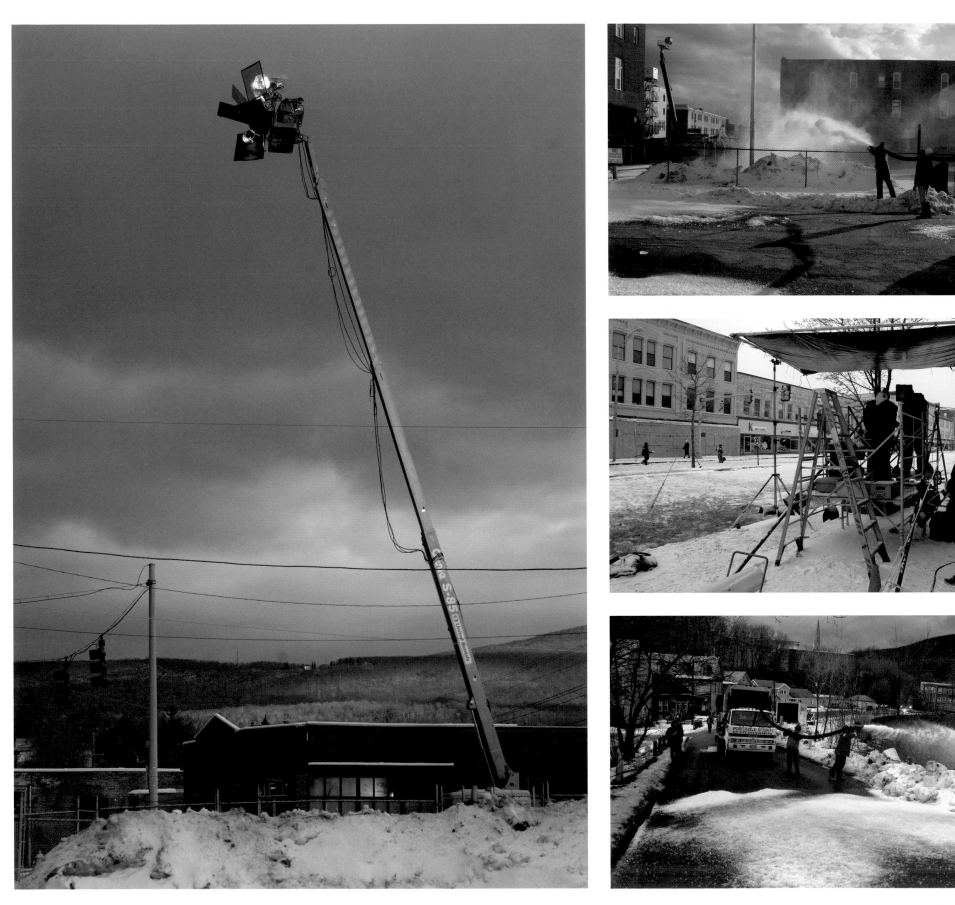

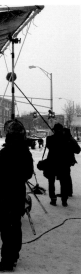

CLOCKWISE FROM LEFT: PRODUCTION STILL, KEVIN KENNEFICK, WINTER 2006; PRODUCTION STILL, DANIEL KARP, WINTER 2006; PRODUCTION STILL, KEVIN KENNEFICK, WINTER 2006; PRODUCTION STILL, DANIEL KARP, WINTER 2006

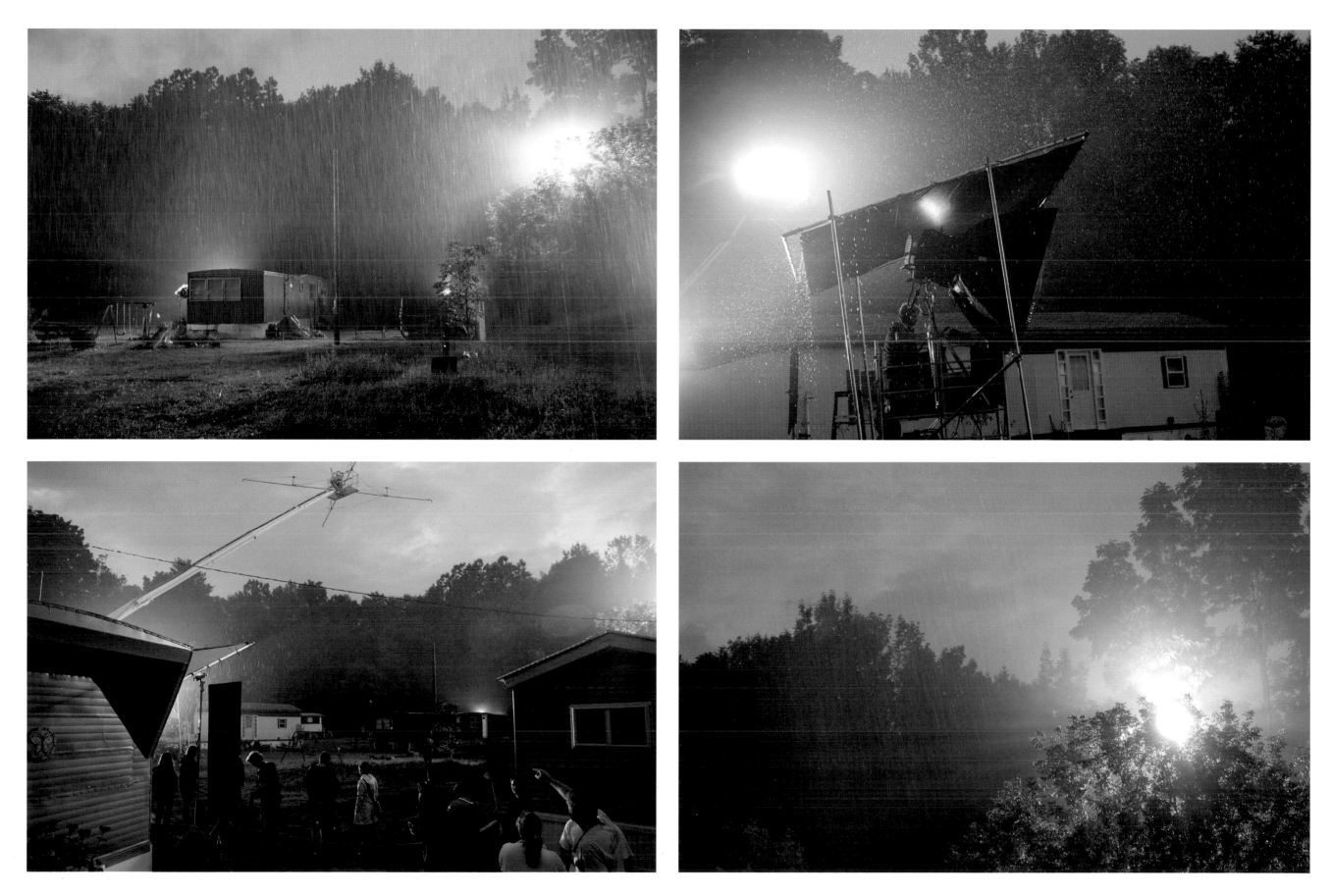

CLOCKWISE FROM TOP LEFT: PRODUCTION STILL, COSTANZA THEODOLI-BRASCHI, SUMMER 2007; PRODUCTION STILL, TREY EDWARDS, SUMMER 2007; PRODUCTION STILL, COSTANZA THEODOLI-BRASCHI, SUMMER 2007; PRODUCTION STILL, TREY EDWARDS, SUMMER 2007

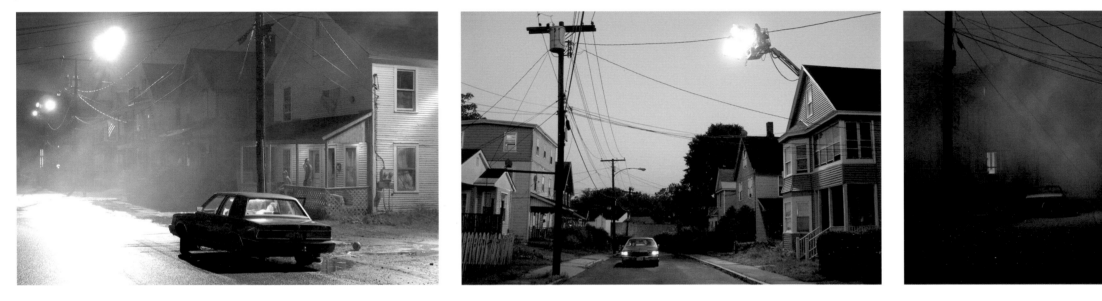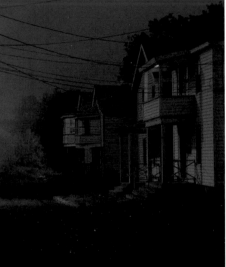

FROM LEFT: PRODUCTION STILL, KEVIN RAPF, SUMMER 2003; PRODUCTION STILL, JOANNE KIM, SUMMER 2006; PRODUCTION STILL, TREY EDWARDS, SUMMER 2006

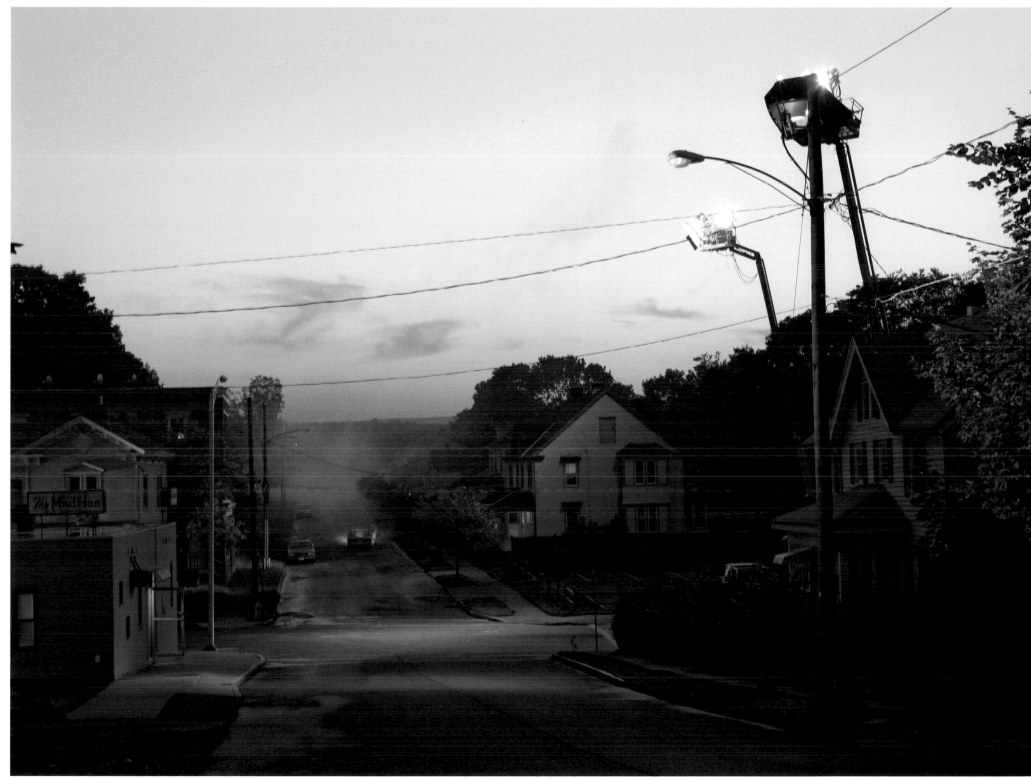

PRODUCTION STILL, COSTANZA THEODOLI-BRASCHI, SUMMER 2007

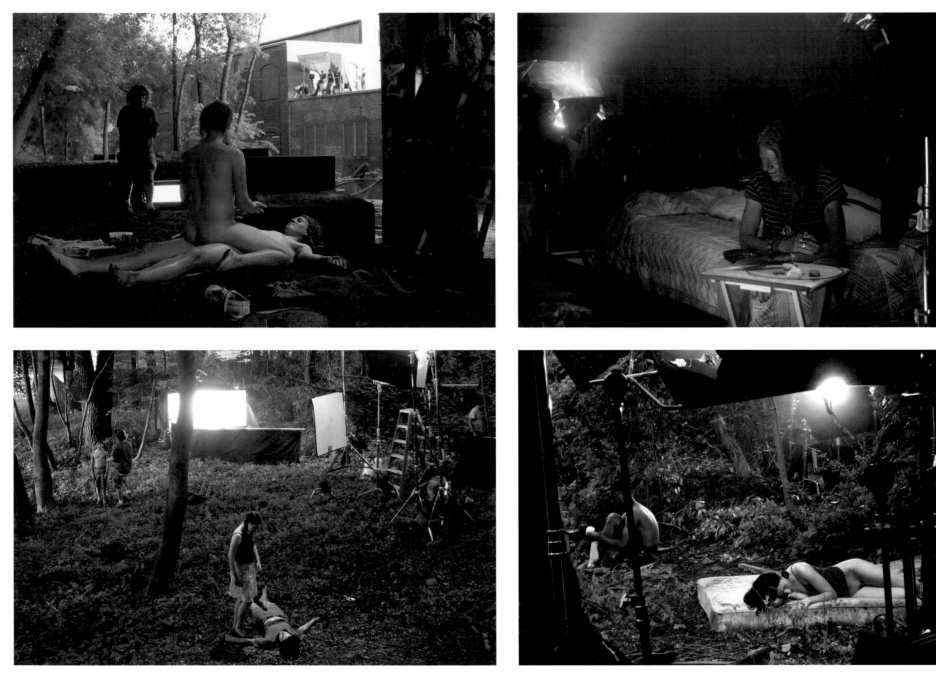

CLOCKWISE FROM TOP LEFT: PRODUCTION STILL, JOANNE KIM, SUMMER 2006; PRODUCTION STILL, COSTANZA THEODOLI-BRASCHI, SUMMER 2007; PRODUCTION STILLS, COSTANZA THEODOLI-BRASCHI, SUMMER 2006

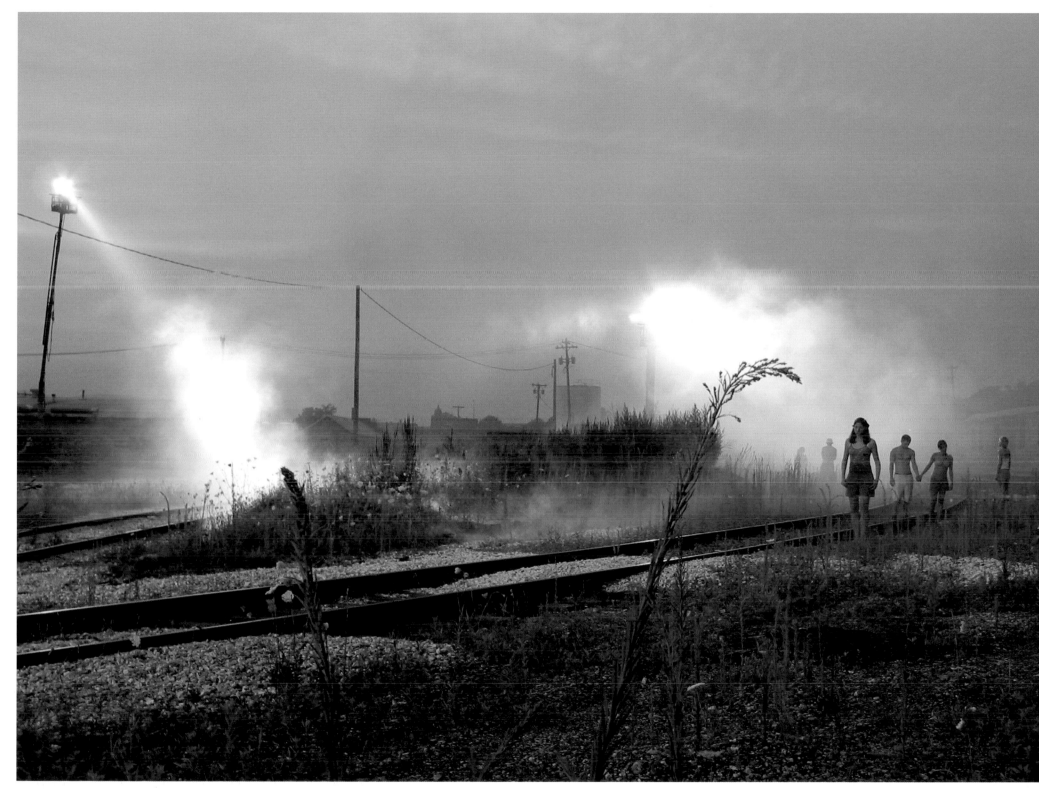

PRODUCTION STILL, KEVIN RAPF, SUMMER 2003

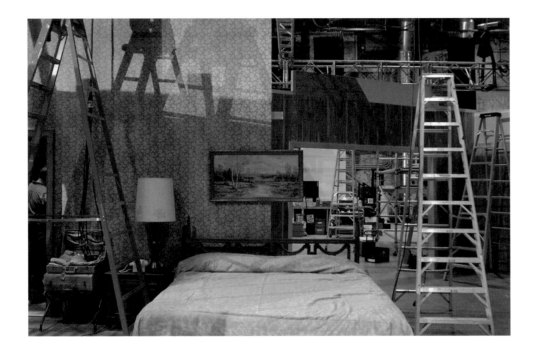

PRODUCTION STILL, DANIEL KARP, WINTER 2005

SOUNDSTAGE

What follows is documentation from the making of the "Beneath the Roses" soundstage pictures, made on the Hunter Soundstage at MASS MoCA in North Adams, Massachusetts, in three productions. These productions took place in the winters of 2004, 2005, and 2007. The following material consists of production stills, set drawings, architectural plans, lighting plots, and Polaroids from these shoots.

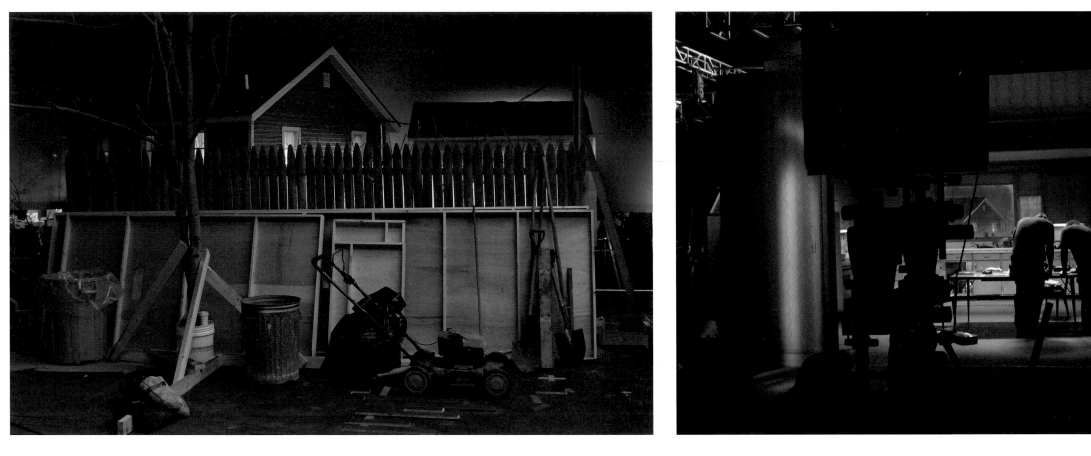 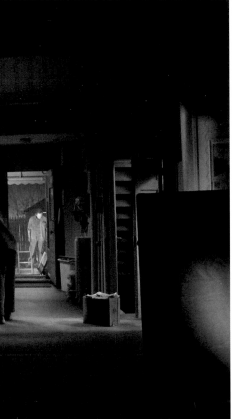

PRODUCTION STILLS, COSTANZA THEODOLI-BRASCHI, WINTER 2007

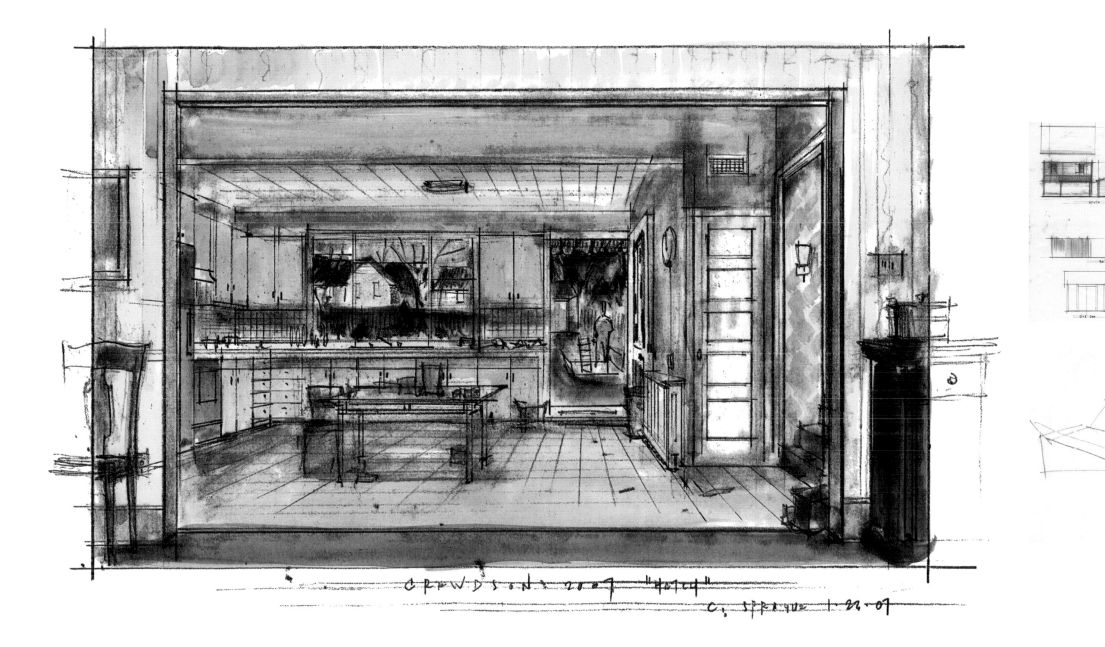

CLOCKWISE FROM LEFT: FINAL SET SKETCH, CARL SPRAGUE, WINTER 2007; ARCHITECTURAL RENDERING, CARL SPRAGUE, WINTER 2007; SET SKETCH, CARL SPRAGUE, WINTER 2007

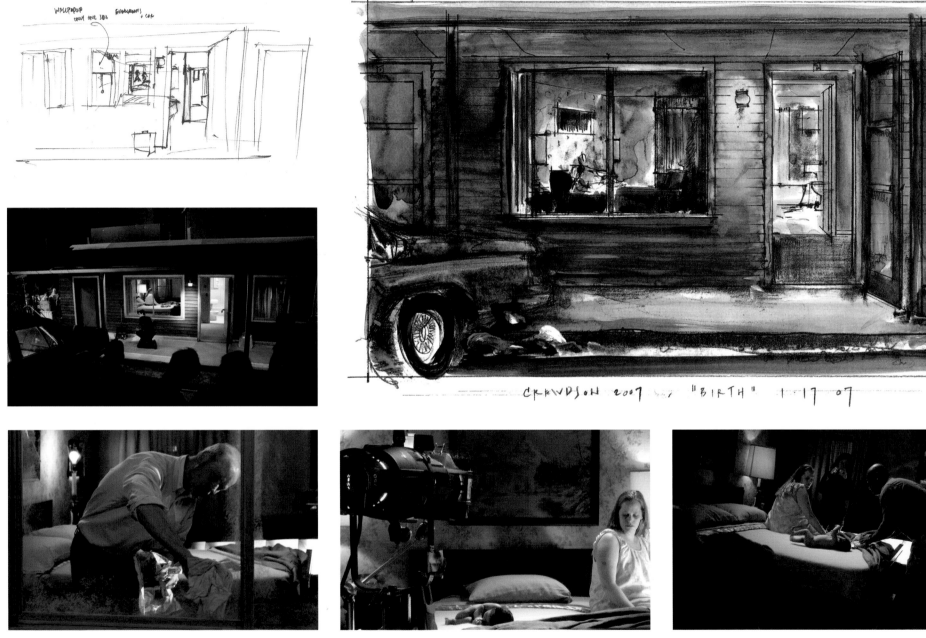

CLOCKWISE FROM TOP LEFT: SET SKETCH, CARL SPRAGUE, WINTER 2007; FINAL SET SKETCH, CARL SPRAGUE, WINTER 2007; PRODUCTION STILL, PETE DEEVAKUL, WINTER 2007; PRODUCTION STILL, COSTANZA THEODOLI-BRASCHI, WINTER 2007; PRODUCTION STILLS, PETE DEEVAKUL, WINTER 2007

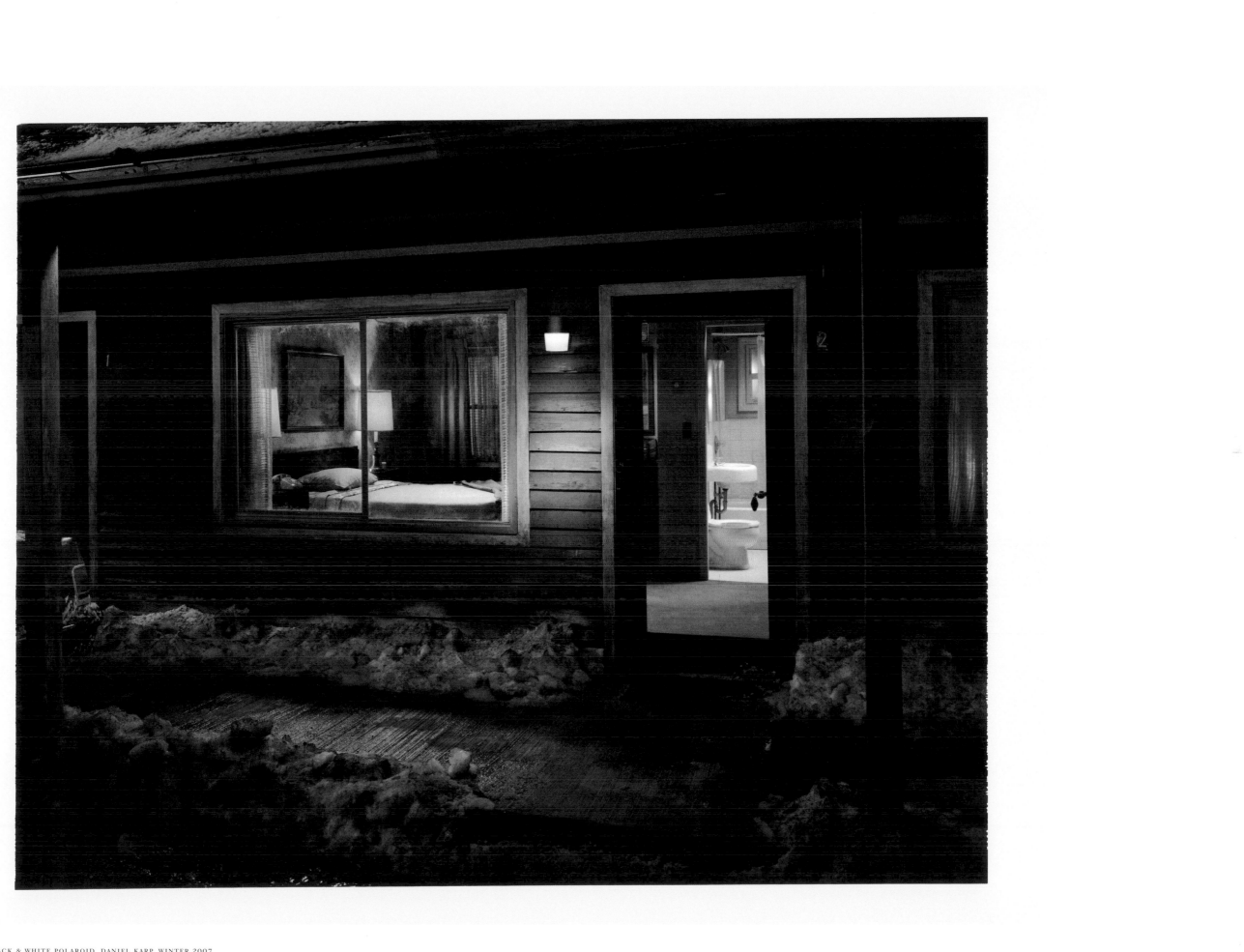

8 x 10" BLACK & WHITE POLAROID, DANIEL KARP, WINTER 2007

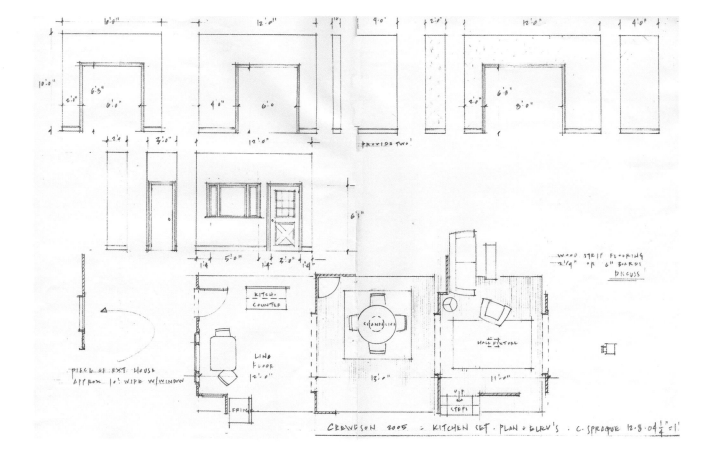

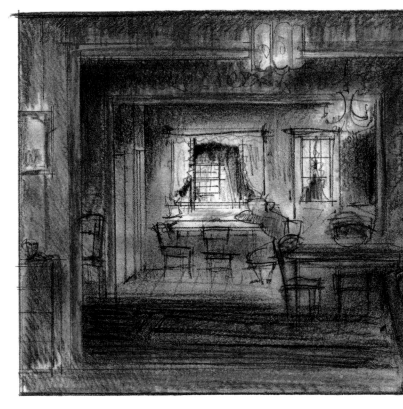

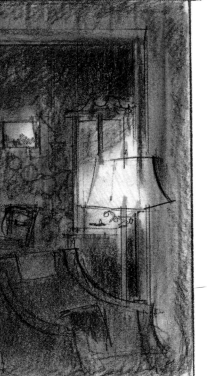

CREWDSON 2005 · KITCHEN SET · PLAN & ELEV'S · C. SPRAGUE 12·8·04 ¼"=1'

FROM LEFT: ARCHITECTURAL RENDERING, CARL SPRAGUE, WINTER 2005; FINAL SET SKETCH, CARL SPRAGUE, WINTER 2005

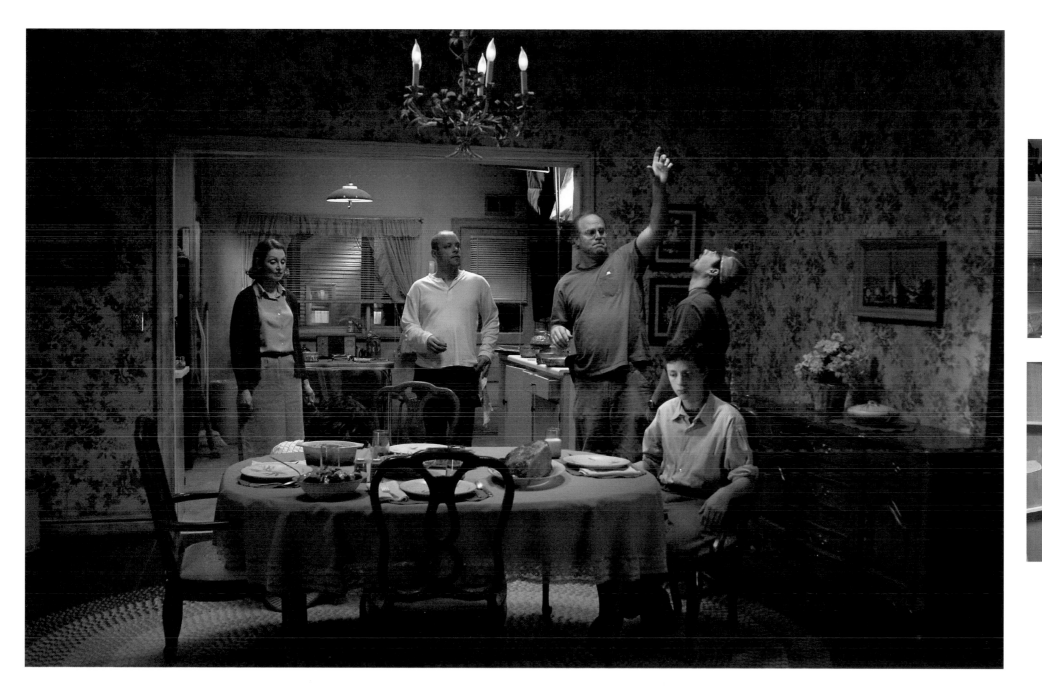

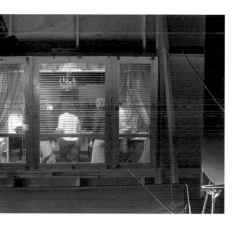

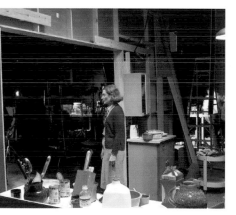

CLOCKWISE FROM LEFT: PRODUCTION STILL, DANIEL KARP, WINTER 2005; PRODUCTION STILL, ZACH FECHHEIMER, WINTER 2005; PRODUCTION STILL, DANIEL KARP, WINTER 2005

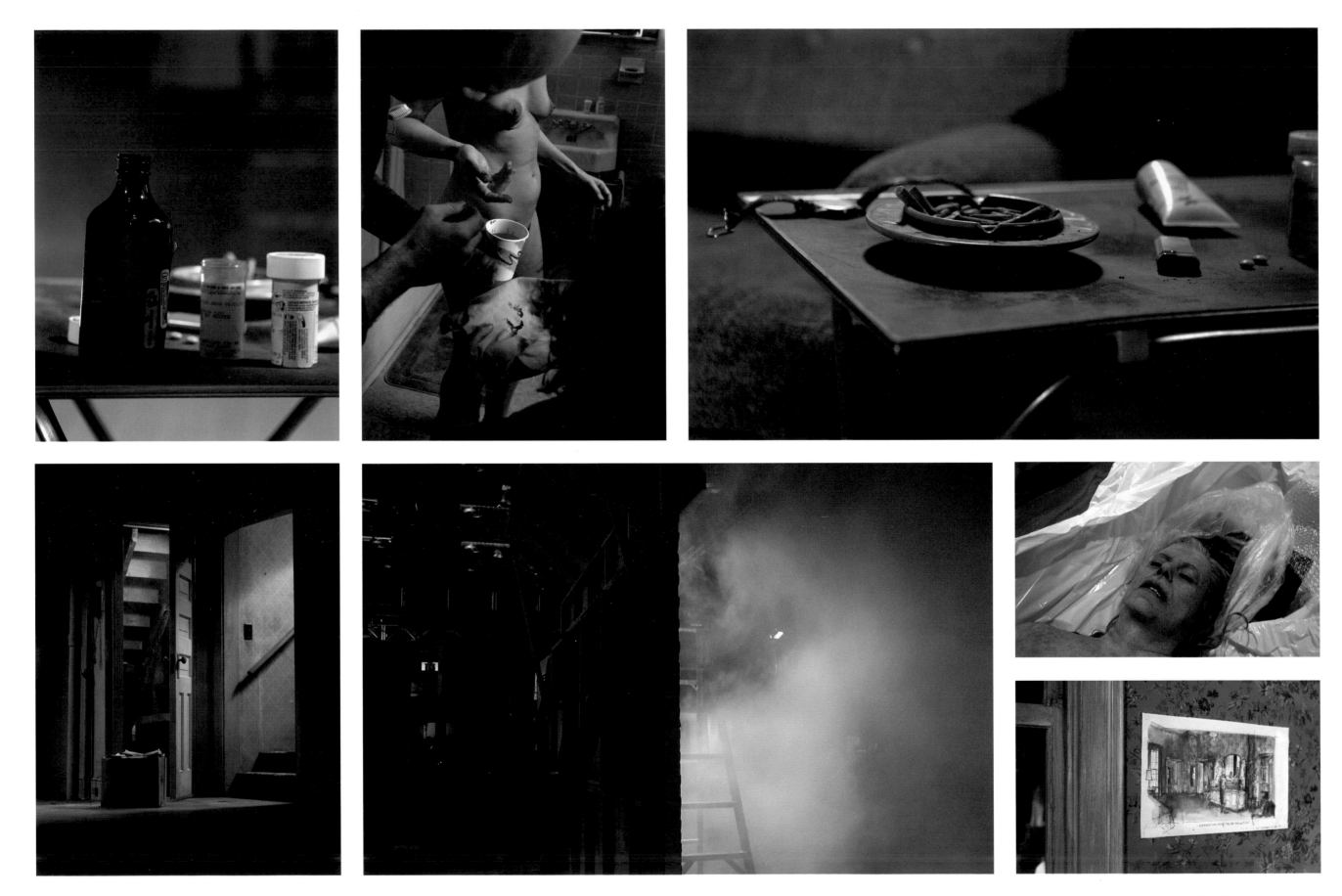

CLOCKWISE FROM TOP LEFT: PRODUCTION STILL, DANIEL KARP, WINTER 2007; PRODUCTION STILL, DANIEL KARP, WINTER 2005; PRODUCTION STILL, DANIEL KARP, WINTER 2007; PRODUCTION STILL, DANIEL KARP, WINTER 2004; PRODUCTION STILL, DANIEL KARP, WINTER 2007; PRODUCTION STILL, COSTANZA THEODOLI-BRASCHI, WINTER 2007; PRODUCTION STILL, DANIEL KARP, WINTER 2007

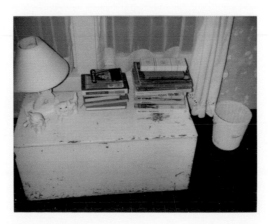
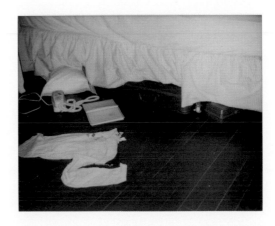

PROP DETAILS, ART DEPARTMENT, WINTER 2004

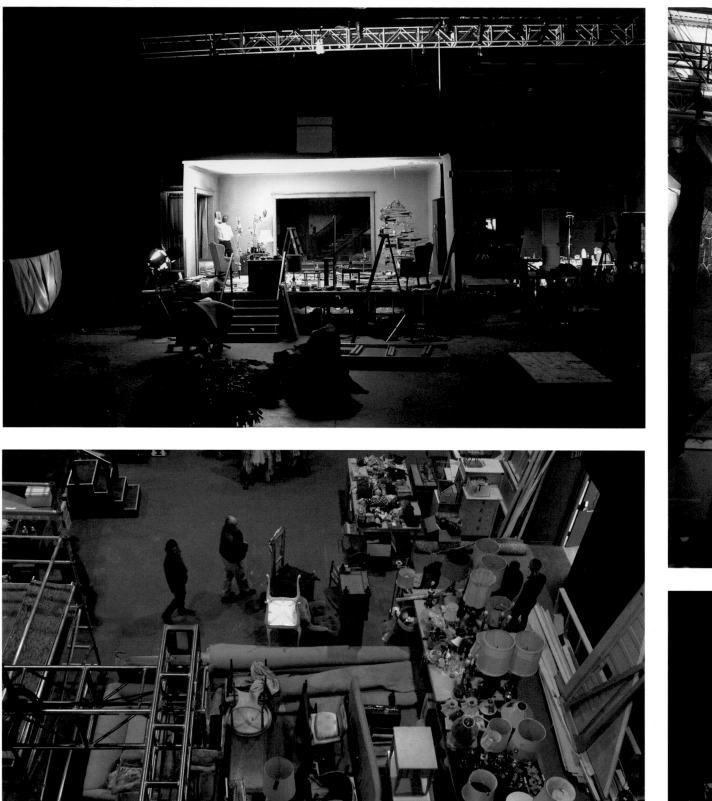
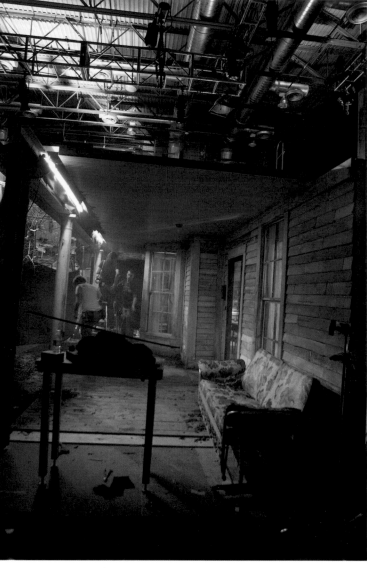
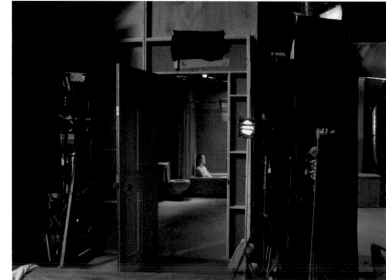

CLOCKWISE FROM TOP LEFT: PRODUCTION STILL, KEVIN KENNEFICK, WINTER 2004; PRODUCTION STILL, PETE DEEVAKUL, WINTER 2007; PRODUCTION STILL, PETE DEEVAKUL, WINTER 2007; PRODUCTION STILL, DANIEL KARP, WINTER 2005

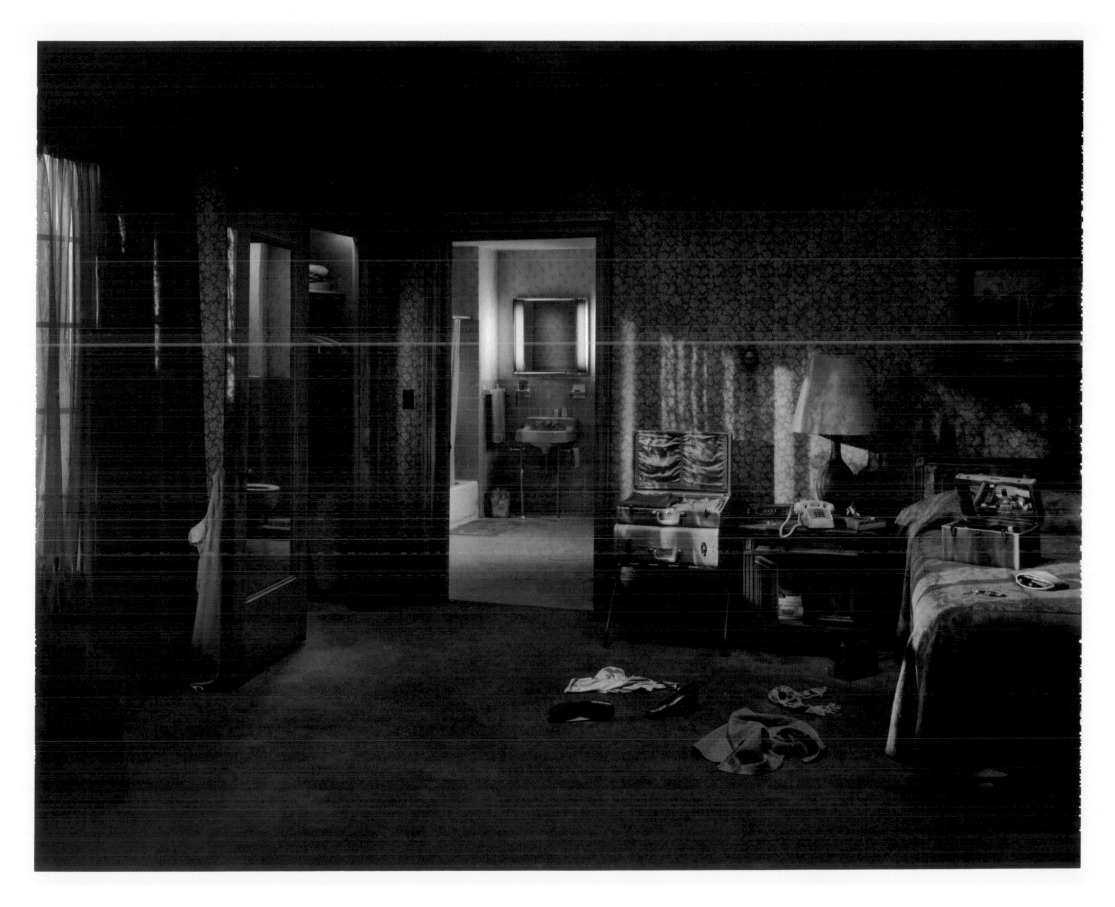

8 x 10" BLACK & WHITE POLAROID, DANIEL KARP, WINTER 2005

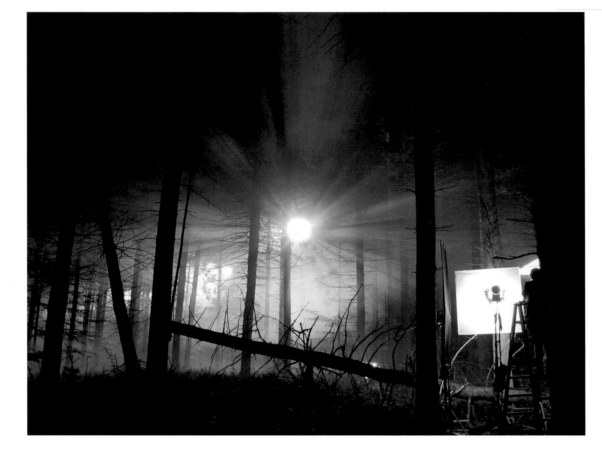

PRODUCTION STILL, KEVIN RAPF, SUMMER 2003

PRODUCTION CREDITS

SUMMER 2007 PRODUCTION

DIRECTOR OF PHOTOGRAPHY
Richard Sands

CAMERA OPERATOR
Daniel Karp

PRODUCER
Saskia Rifkin

ASSISTANT TO THE ARTIST/
PRODUCTION DESIGNER
Costanza Theodoli-Braschi

PRODUCTION MANAGER
Charlie Dibe

PRODUCTION COORDINATOR
Catherine A. Gulácsy

UNIT MANAGER
Hannah Johnson

PRODUCTION ASSISTANT
Charles Atherton

CAMERA ASSISTANT
Trey Edwards

PRODUCTION ACCOUNTANT
J.R. Craigmile

Lighting & Grip Department

GAFFERS
Marcus Lehmann
Karl Schroder

BEST BOY ELECTRIC
Luke Deikis

ELECTRICS
Mark Beattie
Art Meyerhoff
Jean Schroder
Yoshi Sonoda

KEY GRIP
Bill Amenta

BEST BOY GRIP
Jason Sarrey

GRIPS
Patrick Garstin
Brandon Taylor
Ethan Wilhelm

Art Department

PROPS
Ian Noel
Corey Tredtin

SPECIAL EFFECTS
COORDINATOR
Peter Kunz

SPECIAL EFFECTS
Michelle Lydon
Rowan Kunz
Todd Harlan Morehouse
David Root

GREENSMAN
Bill Markham

Locations

LOCATION MANAGER
Sarah Crofts

ASSISTANT LOCATION
MANAGER
Chris Coyne

LOCATION ASSISTANT
Amanda Hartlage

Transportation

G&E DRIVER
Erik Guldbech

Casting

CASTING DIRECTOR
Juliane Hiam

WINTER 2007 PRODUCTION

DIRECTOR OF PHOTOGRAPHY
Richard Sands

CAMERA OPERATOR
Daniel Karp

PRODUCER
Saskia Rifkin

ASSISTANT TO THE ARTIST
Costanza Theodoli-Braschi

PRODUCTION MANAGER
Charlie Dibe

PRODUCTION COORDINATOR
Jane Yakowitz

CAMERA ASSISTANT
Pete Deevakul

PRODUCTION ACCOUNTANT
J.R. Craigmile

Lighting & Grip Department

GAFFER
Marcus Lehmann

BEST BOY ELECTRIC
Luke Deikis

ELECTRICS
Liz Campbell
Jean Schroder
Yoshi Sonoda

KEY GRIP
James Heerdegen

BEST BOY GRIP
Nick Haines-Stiles

GRIPS
Bobby Boothe
John Gatland
Karl Schroder

Art Department

PRODUCTION DESIGNER
Carl Sprague

ASSISTANT TO THE
PRODUCTION DESIGNER
Tyler Moynihan

ART DEPARTMENT
COORDINATOR
Michelle Quigley

SET DECORATOR
Jennifer Engel

ASSISTANT SET DECORATOR
Paige Carter

SET DRESSERS
Jason Massaro
Beth Peterson

PROP MASTER
Ryan Webb

ASSISTANT PROP MASTER
Courtney Schmidt

GREENSMAN
Bill Markham

CHARGE SCENIC
Dan Courchaine

SCENICS
Hope Ardizzone
Paula Bird
Julia Garrison
Terry Sylvester

CONSTRUCTION
COORDINATORS—PREP
Dion Robbins-Zust
Kurt Smith

CONSTRUCTION
COORDINATOR—SHOOT
Kurt Smith

MASTER CARPENTER
Jim Burkholder

SET CARPENTERS
Bryan Mountz
David Woods

Hair & Makeup
Maya Hardinge

Casting

CASTING DIRECTOR
Caroline Sinclair

CASTING COORDINATOR
Juliane Hiam

*MASS MoCA In-House
Soundstage Crew*

MANAGING DIRECTOR OF
PERFORMING ARTS & FILM
Sue Killam

SOUNDSTAGE PRODUCTION
MANAGERS
Eric Enderle
Eric Nottke

COMPANY MANAGER
Meghan Robertson

SUMMER 2006 PRODUCTION

DIRECTOR OF PHOTOGRAPHY
Richard Sands

CAMERA OPERATOR
Daniel Karp

PRODUCER
Saskia Rifkin

ASSISTANT TO THE ARTIST/
PRODUCTION DESIGNER
Costanza Theodoli-Braschi

PRODUCTION MANAGER
Charlie Dibe

UNIT MANAGER/CASTING
COORDINATOR
Jessie Thurston

OFFICE COORDINATOR
Joanne Kim

PRODUCTION ASSISTANT
Ryan Macphee

DIGITAL COORDINATOR/
CAMERA ASSISTANT
Trey Edwards

PRODUCTION ACCOUNTANT
Mikhael Antone

Lighting & Grip Department

GAFFER
Marcus Lehmann

BEST BOY ELECTRICS
Art Meyerhoff
Cristian Trova

ELECTRICS
Aida Artieda
Luke Deikis
Jean Schroder
Yoshi Sonoda

KEY GRIP
James Heerdegen

BEST BOY GRIP
Nick Haines-Stiles

GRIPS
Bill Amenta
Bobby Boothe
John Gatland
Karl Schroder

Art Department

PROPS
Neal Giberti
Ian Noel

GREENSMAN
Bill Markham

Locations

LOCATION MANAGER
Sarah Crofts

ASSISTANT LOCATION
MANAGER
Chris Coyne

LOCATION ASSISTANTS
Daniel Fitzsimmons
Lauren Kneeland
Beau Tipton

Transportation

TRANSPORT COORDINATOR
Neal Giberti

TRANSPORT ASSISTANT
Ian Noel

G&E DRIVER
Bob Lesser

Casting

CASTING DIRECTOR
Juliane Hiam

WINTER 2006 PRODUCTION

DIRECTOR OF PHOTOGRAPHY
Richard Sands

CAMERA OPERATOR
Daniel Karp

PRODUCER
Saskia Rifkin

PRODUCTION MANAGER
Mara Bodis-Wollner

PRODUCTION COORDINATOR
Charlie Dibe

ASSISTANT TO THE ARTIST/
PRODUCTION DESIGNER
Costanza Theodoli-Braschi

UNIT MANAGER
Jessie Thurston

DIGITAL COORDINATOR/
CAMERA ASSISTANT
Trey Edwards

PRODUCTION ACCOUNTANT
Rebecca Garland

Lighting & Grip Department

GAFFER
Scott Mahler

BEST BOY ELECTRIC
Rick Morrison

ELECTRICS
Liz Campbell
Eric Engler
Marcus Lehmann
Tom Von
Allen Zellman

KEY GRIP
Brent Poleski

BEST BOY GRIP
James Heerdegen

GRIPS
Nick Haines-Stiles
Brian Sachson
Jonathan Stern

Art Department

PROPS
Neal Giberti
Ian Noel

GREENSMAN
Bill Markham

SPECIAL EFFECTS
COORDINATOR
JC Brotherhood

SPECIAL EFFECTS
Nathanael Brotherhood
Jason Griffin
Michelle Lydon
Mike Murphy
David Root

Locations

LOCATION MANAGER
Sarah Crofts

ASSISTANT LOCATION
MANAGER
Chris Coyne

LOCATION ASSISTANTS
Paige Carter
Alex Meriwether
Tenaya Plowman

Transportation

TRANSPORT COORDINATOR
Neal Giberti

TRANSPORT ASSISTANT
Ian Noel

G&E DRIVER
Bob Lesser

Casting

CASTING COORDINATORS
Costanza Theodoli-Braschi
Jessie Thurston

WINTER 2005 PRODUCTION

DIRECTOR OF PHOTOGRAPHY
Richard Sands

CAMERA OPERATOR
Daniel Karp

PRODUCER
Saskia Rifkin

PRODUCTION MANAGER
Mara Bodis-Wollner

PRODUCTION COORDINATOR
Charlie Dibe

UNIT MANAGER
Jessie Thurston

PRODUCTION ASSISTANT
Sandra Gartner

PRODUCTION ACCOUNTANT
Hillary Meyer

Lighting & Grip Department

GAFFER
Deidre Lally

BEST BOY ELECTRIC
John Woods

ELECTRICS
Jean Chen
Marcus Lehmann
Marc Stetz
Zach Zamboni

KEY GRIP
Brent Poleski

BEST BOY GRIP
Karl Schroder

GRIPS
John Dianda
Chris Koch
Charles Wing

Art Department

PRODUCTION DESIGNER
Carl Sprague

ASSISTANT TO THE
PRODUCTION DESIGNER
Costanza Theodoli-Braschi

SET DECORATOR
Kyra Friedman

LEAD MAN
Robert Schleinig

SHOPPER
Paige Carter

SET DRESSER
Jennifer Engel

CHARGE SCENIC
Dan Courchaine

SCENICS
David Costello
Julia Garrison

PROP MASTER
Ryan Webb

ASSISTANT PROP MASTERS
Catriona Crosby
Neal Giberti
Colin Montgomery

CONSTRUCTION COORDINATOR
Dion Robbins-Zust

SET CARPENTERS
Gary Bourdon
John Capron

TANK ENGINEER
John Cox

TANK MASTER FABRICATORS
John Carli
Richard Criddle
Tom Merril

AQUARIST
Scott Jervas

Hair & Makeup
Maya Hardinge

Wardrobe
Mei-Lai Hippisley-Cox

Casting

CASTING DIRECTOR
Caroline Sinclair

*MASS MoCA In-House
Soundstage Crew*

MANAGING DIRECTOR OF
PERFORMING ARTS & FILM
Sue Killam

SOUNDSTAGE PRODUCTION
MANAGER
Larry Smallwood

PRODUCTION MANAGER FOR
PERFORMING ARTS & FILM
Eric Nottke

PRODUCTION COORDINATOR
FOR PERFORMING ARTS &
FILM
Eric Enderle

COMPANY MANAGER
Meghan Robertson

MASS MoCA CREW
Jason Irons
Keith Nogueira
Michael Pontier
Don Williams

SUMMER 2004 PRODUCTION

DIRECTOR OF PHOTOGRAPHY
Richard Sands

CAMERA OPERATOR
Daniel Karp

PRODUCER
Saskia Rifkin

PRODUCTION MANAGER
Melanie Willhide

UNIT MANAGER/CASTING
COORDINATOR
Jessie Thurston

CAMERA ASSISTANT
Sarah Crofts

PRODUCTION ASSISTANTS
Shaun Fogarty
Sandra Gartner
Julie Trotta
Jeremiah Zagar

Lighting & Grip Department

GAFFER
Deidre Lally

BEST BOY ELECTRIC
Erik Messerschmidt

ELECTRICS
Jean Chen
Matt Craig
PJ Gaynard
Marcus Lehmann
Art Meyerhoff
Mark Stetz
Zach Zamboni

KEY GRIP
Brent Poleski

BEST BOY GRIP
Karl Schroder

GRIPS
James Heerdegen
Chris Koch
Che Roacher
Charles Wing

Art Department

SPECIAL EFFECTS
COORDINATOR
JC Brotherhood

SPECIAL EFFECTS
Nathanael Brotherhood
Jason Griffin
Michelle Lydon
Mike Murphy
David Root

CONSTRUCTION COORDINATOR
Dion Robbins-Zust

PROPS
Jason Giberti
Neal Giberti

Locations

LOCATION MANAGER
Laura J. Berning

LOCATION ASSISTANTS
Karyn Behnke
Paige Carter
Sarah Crofts

Transportation

TRANSPORT COORDINATOR
Neal Giberti

TRANSPORT ASSISTANT
Jason Giberti

G&E DRIVER
John Alba

WINTER 2004 PRODUCTION

DIRECTOR OF PHOTOGRAPHY
Richard Sands

CAMERA OPERATOR
Daniel Karp

PRODUCTION MANAGER
Melanie Willhide

UNIT MANAGER/CASTING
COORDINATOR
Jessie Thurston

Lighting & Grip Department

GAFFER
Deidre Lally

BEST BOY ELECTRIC
Erik Messerschmidt

ELECTRICS
Jean Chen
Marcus Lehmann
Kris Nutting
Mark Stetz

KEY GRIP
Brent Poleski

BEST BOY GRIP
Karl Schroder

GRIPS
Matt Craig
Catriona Crosby
Chris Koch
Nick Leon
Cristian Trova

Art Department

PRODUCTION DESIGNER
Anne Ross

ASSISTANT TO THE
PRODUCTION DESIGNER
Jeremy McFarlane

ART DIRECTOR
Carl Sprague

ASSISTANT ART DIRECTOR
Philip Winn

SET DECORATOR
Whitney Delgado

SHOPPER
Paige Carter

SET DRESSERS
John Capron
Neal Giberti
Adam Gold
Jay Heyman
Ryan Webb

LEAD GREENSMAN
Buzz Gray

GREENSMAN
Bill Markham

GREENS CREW
Lee Bouchard
Fran Fusco
Kristen Gray
Tim Herrick
Tom Knight
Claude Sloan

CHARGE SCENIC
Dan Courchaine

SCENICS
David Costello
Mary Hopkins
Sarah Johnson
Eric Levenson

PROP MASTER/SPECIAL
EFFECTS SUPERVISOR
Paul Richards

CONSTRUCTION COORDINATOR
Kurt Smith

MASTER CARPENTER
Dion Robbins-Zust

SET CARPENTERS
Gary Bourdon
Tom Merrill
Bryan Mountz
Matthew Payette
Mike Wise

MODEL MAKER
William Sweet

Transportation
Shaun Fogarty
Neal Giberti
Shea Kiley

Hair & Makeup

HAIR
Dennis Devoy

MAKEUP
Annie Armstrong
Valerie Willhide

Wardrobe
Emily Rebholz

Casting

CASTING COORDINATORS
Jenny Gersten
Caroline Sinclair

*MASS MoCA In-House
Soundstage Crew*

DIRECTOR OF PERFORMING
ARTS & FILM
Jonathan Secor

GENERAL MANAGER FOR
PERFORMING ARTS & FILM
Sue Killam

SOUNDSTAGE PRODUCTION
MANAGER
Larry Smallwood

PRODUCTION MANAGER FOR
PERFORMING ARTS & FILM
Eric Nottke

MASS MoCA CREW
Jason Irons
Keith Nogueira
Michael Pontier
Don Williams

SUMMER 2003 PRODUCTION

DIRECTOR OF PHOTOGRAPHY
Richard Sands

CAMERA OPERATOR
Daniel Karp

PRODUCTION MANAGER
Melanie Willhide

PRODUCTION COORDINATOR
Sandra Gartner

Lighting & Grip Department

GAFFER
Deidre Lally

BEST BOY ELECTRIC
Eric Messerschmidt

ELECTRICS
Jean Chen
Marcus Lehmann
Ethan Vogt

KEY GRIP
Wilson Tang

BEST BOY GRIP
Cristian Trova

GRIP
Catriona Crosby

Art Department

PROPS
Jason Giberti
Neal Giberti
Kevin Rapf

SET CARPENTER
Barry Astros

PYROTECHNICS
Ron Marcus

Transportation

TRANSPORT COORDINATOR
Neal Giberti

TRANSPORT ASSISTANTS
Jason Giberti
Kevin Rapf

Casting
Jenny Gersten

2003–2007

POST-PRODUCTION

MASTER PRINTER/DIGITAL
ARTIST
Kylie Wright

DIGITAL PRINTER
John Lehr

DIGITAL PRINTER/
COORDINATOR
Trey Edwards

DIGITAL ARTIST
Geraldine Lucid

PRINTER
Anna Collette

VISUAL EFFECTS SUPERVISOR
FOR SPECIAL PROJECTS
John Nugent

COMPUTER GRAPHICS
SUPERVISOR/MOTH DESIGN
Michael Gray

DIGITAL SCANNER
David Leventi

PRODUCTION STILLS

Laura Berning
Pete Deevakul
Trey Edwards
Marten Elder
Daniel Karp
Kevin Kennefick
Joanne Kim
Kevin Rapf
Costanza Theodoli Bracchi

PRODUCTION INTERNS

Mira Aldridge
Michael Arisohn
Charles Atherton
Vanessa Badino
Adda Birnir
Charlie Birns
Daniel Bogenhagen
Sena Clara Creston
Liza Curtiss
Marten Elder
Morgan Elliott
Zane Enloe
Zach Fechheimer
Matti Fisher
Jayme Fraioli
Julia Goldman
Sarah Hack
Sarah Roberts Hale
Gregory Holm
Thomas Hooker
Josh Huffman
Ivan Iannoli
Marion Jackson
Hannah Johnson
Sarah Johnson
Caity Judd
Elliya Kane
Shea Kiley
Keehnan Konyha
Mindy Koopmans
Lane Koster
Colette Kulig
Eloise Marks
Timothy Meagher
Alex Meriwether
Greg Mitchell
Matthew Payette
Heather Phillips

Robert Pickard
Tenaya Plowman
Mike Powsner
Kevin Rapf
Jacob Rhodes
Dick Rohe
Allison Scheer
Kristen Scheer
Julia Sherman
Ani Simon-Kennedy
Henry Smith
Josh Tiska
Julie Trotta
Jesse Tucker
Elisabeth Vella
Ven Voisey
Sadie Wechsler
Jeremiah Zagar
Adam Zax
Arianna Zindler

PRODUCTION SUPPORT

PRINTING
Epson America, Inc.
Laumont Photographics

VISUAL EFFECTS
Sandbox Pictures

FILM PROCESSING
LTI New York

FRAMING
Bark Framework
Minagawa Art Lines

LIGHTING PACKAGE AND
EQUIPMENT
Eastern Effects
Edgewood Studios
Expendables Plus
K/A/S Lighting
Leonetti Lighting
Limelight Productions

HOUSE DEMOLITION
Variety Trucking and Demolition

LODGING
Jiminy Peak
The Porches Inn

CATERING
How Sweet It Is
Lickety Split

SECURITY
Ron Munoz

LEGAL
Stout & Thomas

INSURANCE
Dennis Reiff & Associates

PAYROLL
Axium

WEATHER PROGNOSTICATOR
George Trottier

ADDITIONAL SUPPORT

Joyce Bernstein and
 Larry Rosenthal
Joanne Derose
Nancy Fitzpatrick
Matt Hill
Jeff Hirsch
Meryl Joseph
Jeffrey Kane
Philippe Laumont
Yasuo Minagawa
John Nugent
Dan Steinhardt
Nancy Thomas

TOWNS AND CITIES

TOWN OF ADAMS, MA
William Ketchum, Town
 Administrator
Donald Piorot, Police Chief
Steven Brown, Fire Chief
Jim Belanger, Water Supervisor
Donna Cesan, Adams
 Community Development
 Dept.

TOWN OF CHESHIRE, MA
Mark Weiser, Town Administrator

CITY OF NORTH ADAMS, MA
John Barrett III, Mayor
Michael Cozzaglio, Police
 Director
Stephen Meranti, Fire Director
E. John Morocco, Commissioner
 of Public Safety

CITY OF PITTSFIELD, MA
James M. Ruberto, Mayor
Lisa Wiehl, Assistant to the
 Mayor
Paula King, Mayor's Office
John Krol, Mayor's Office
Anthony Riello, Police Chief
Steven Duffy, Fire Chief
James Sullivan, Fire Chief
Carmen Massimiano, Jr., Sheriff
Matt Hill, Sergeant
Tom Satko, Water Supervisor
Housatonic Railroad

CITY OF RUTLAND, VT
John Cassarino, Mayor
Kevin E. Geno, Police Chief
Bob Schachter, Fire Chief
R.J. Elrick, Sheriff
John Havens, Water Supervisor
Ted Pratt, Park Ranger
Vermont Railways, Inc.

All exhibition prints *Untitled*, 2003–2007
Digital pigment prints
57 x 88 inches (144.8 x 223.5 cm)

ACKNOWLEDGMENTS

I would like to thank the following for their contributions in making the pictures:

Rick Sands for his masterful use of light and Daniel Karp for his unwavering support behind the camera. Saskia Rifkin for her expertise in overseeing every aspect of the production. Cosi Theodoli-Braschi for her invaluable insight and involvement with the artwork.

Kylie Wright for her digital artistry. Anna Collette and Trey Edwards for their additional work in post-production.

Roland Augustine and Lawrence Luhring for their ongoing belief and support in the artwork. Jay Jopling and Larry Gagosian for their commitment to co-producing the work. Natalia Mager-Sacasa, Sarah Watson, Daniella Gareh, Tim Marlow, and Craig Burnett for additional gallery support.

Joe Thompson and the entire staff of MASS MoCA for generous use of their facilities.

Russell Banks for his eloquent and insightful words.

Deborah Aaronson and Miko McGinty for overseeing the production of this book.

I would like to express my profound gratitude to my parents, Frank and Carole Crewdson, and to my brother and sister, Michael and Natasha. And finally, to my wife, Ivy, and two children, Lily and Walker, for their eternal love and support.

PAGE 2: PRODUCTION STILL, KEVIN RAPF, SUMMER 2003

Editor: Deborah Aaronson
Designers: Miko McGinty and Rita Jules
Production Manager: Anet Sirna-Bruder

LIBRARY OF CONGRESS CATALOGING-IN-PUBLICATION DATA
Crewdson, Gregory.
 Beneath the roses / Gregory Crewdson ; essay by Russell Banks.
 p. cm.
 ISBN 978-0-8109-9380-8
 1. Photography, Artistic. 2. Crewdson, Gregory. I. Banks, Russell, 1940-
 II. Title.
 TR655.C74 2008
 779.092—dc22 2007025809

Copyright © 2008 Gregory Crewdson
Essay copyright © 2008 Russell Banks

Published in 2008 by Abrams, an imprint of Harry N. Abrams, Inc.
All rights reserved. No portion of this book may be reproduced, stored in a retrieval system, or transmitted in any form or by any means, mechanical, electronic, photocopying, recording, or otherwise, without written permission from the publisher.

Printed and bound in China
10 9 8 7 6 5 4 3 2

Abrams books are available at special discounts when purchased in quantity for premiums and promotions as well as fundraising or educational use. Special editions can also be created to specification. For details, contact specialmarkets@hnabooks.com or the address below.

Harry N. Abrams, Inc.
115 West 18th Street
New York, NY 10011
www.hnabooks.com

INFCW 779
.092
C927

Friends of the
Houston Public Library

CREWDSON, GREGORY
 BENEATH THE ROSES

CENTRAL LIBRARY
11/08